Black Meme

Black Meme

A History of the
Images That Make Us

Legacy Russell

VERSO

London • New York

First published by Verso 2024
© Legacy Russell 2024

1 3 5 7 9 10 8 6 4 2

Verso
UK: 6 Meard Street, London W1F 0EG
US: 388 Atlantic Avenue, Brooklyn, NY 11217
versobooks.com

Verso is the imprint of New Left Books

ISBN-13: 978-1-83976-280-2
ISBN-13: 978-1-83976-282-6 (UK EBK)
ISBN-13: 978-1-83976-283-3 (US EBK)

British Library Cataloguing in Publication Data
A catalogue record for this book is available from the British Library

Library of Congress Cataloging-in-Publication Data

Names: Russell, Legacy, author.
Title: Black meme : a history of the images that make us / Legacy Russell.
Description: London ; New York : Verso, 2024. | Includes bibliographical
 references.
Identifiers: LCCN 2023051876 (print) | LCCN 2023051877 (ebook) | ISBN
 9781839762802 (hardback) | ISBN 9781839762833 (ebook)
Subjects: LCSH: Black people—Race identity—Philosophy. | Visual
 sociology. | Black people in mass media. | Black people and mass
 media—United States—History.
Classification: LCC P94.5.B552 U567 2024 (print) | LCC P94.5.B552 (ebook)
 | DDC 302.2/2608996073—dc23/eng/20240201
LC record available at https://lccn.loc.gov/2023051876
LC ebook record available at https://lccn.loc.gov/2023051877

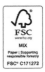

Typeset in Sabon by MJ & N Gavan, Truro, Cornwall
Printed and bound by CPI Group (UK) Ltd, Croydon CR0 4YY

FOR

001 – Saartjie (Sarah) Baartman (born c. 1789, d. 1815), who was sacrificed and extracted from, yet without whom we would not have performance as we now know it.

002 – The unnamed Black jockey riding the named horse "Annie G." featured on plate 626 in Eadweard Muybridge's stop-motion *Animal Locomotion* (1887). Perhaps you were the first Black transmitter to grace the screen, a GIF before the GIF.
Never viral, we wish we knew you.

003 – Saint Suttle and Gertie Brown, who in "Something Good—Negro Kiss" (1898) showed us what Black love could look like on the silver screen.

004 – For Sakia Gunn (1987–2003), failed by the algorithm, but who we remember here. Say her name.

005 – Jalaiah Harmon, who has made history, now, through and beyond the internet.

You are loved.

and i sometimes wonder why i didn't become a
debutante
sitting on porches, going to church all the time,
wondering
is my eye make-up on straight
or a withdrawn discoursing on the stars and moon
instead of a for real Black person who must now feel
and inflict
pain
—Nikki Giovanni, "Adulthood" (1968)

"You did not have the luxury of a browser tab."
—Caleb Azumah Nelson, *Open Water* (2021)

CONTENTS

ILLUSTRATIONS

Inside of this book you will find two sets of images.

The first—printed in black and white and placed at the beginning of each section—is intended as an archival document and illustration, a mark of a changing channel, an opportunity to give you as the reader a brief insight into a moment in time as we travel through it together.

The second set you will find consolidated and printed in color. If the black-and-white images serve to change the channel, this set of color images is an active on-screen broadcast, a visual montage and disruption inside the text itself. There is no formal analysis of each of these artworks in this book; this is intentional as the goal is to have each work exist external to theory dissection and instead function in Black opacity and encryption for the reader. These artists have been invited to share their work because the themes of their creative practices touch on the themes traversed within the body of this text. We are grateful for the choreography this work sets forward, and the ways in which Black art and Black life bow to one another in a limitless and radical exchange.

0.1 Installation view of the exhibition "Projects: Garrett Bradley," November 21, 2020–March 21, 2021. The Museum of Modern Art, New York. Photographer: Robert Gerhardt. Digital Image © The Museum of Modern Art/Licensed by SCALA / Art Resource, NY.

0.2 T. Hayes Hunter, Edwin Middleton, *Lime Kiln Club Field Day* (still), 1914/2014. Courtesy of The Museum of Modern Art, New York.

1.1 Photograph. Lawrence Beitler, 1930.

1.2, 1.3 Postcard. (Back) Source unknown, anonymous eBay listing. (Front) March 3, 1910. Courtesy of the George W. Cook Dallas/Texas Image Collection via Southern Methodist University.

2.1 Dave Mann, "Family of Emmett Till at his burial service," September 6, 1955. ST-17600662, Chicago Sun-Times Collection, Chicago History Museum. © Chicago Sun-Times Media, Inc. All rights reserved.

3.1 Spider Martin, "Two-minute warning, Selma March, Alabama," March 7, 1965. Photograph. © 1965 Spider Martin.

4.1 "The Salute" photograph. Angelo Cozzi, Mondadori Publishers, October 16, 1968.

5.1 Michael Jackson in Michael Jackson's "Thriller," directed by John Landis, 1983. Courtesy of Optimum Productions / Alamy Stock Photo.

6.1 Film poster for Jennie Livingston, *Paris Is Burning*, Miramax Films & Prestige, 1990.

7.1 George Holliday, LA police beating Rodney King (video still), March 3, 1991. From a broadcast on KTLA News, Los Angeles, March 4, 1991.

8.1 Anita Hill giving testimony, October 20, 2010, photograph. © 1992 Associated Press. All rights reserved.

8.2 Magic Johnson retirement announcement, November 7, 1991. Courtesy of Associated Press / Alamy Stock Photo.

9.1 "Dancing Baby" GIF.

10.1 Tamara Lanier holds a 1950 photograph of Renty, July 17, 2018. Courtesy of Associated Press / Alamy Stock Photo. Photo: John Shishmanian, 2018.

11.1 Video by Diamond Reynolds via Facebook, July 16, 2016 (MPR News, "Officer Yanez' squad car video, side-by-side with Diamond Reynods' Facebook video," YouTube video, June 20, 2017, screenshot at 10:50).

Plates

OVERTURE: BLACK PLANETS / BLACK MEMES / BLACK ACTS

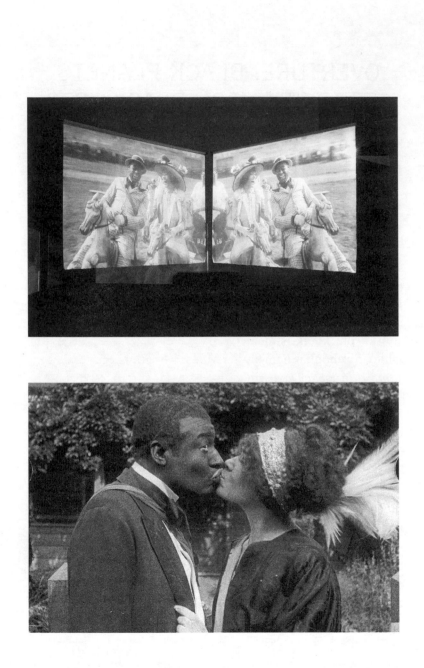

"The history of [B]lackness is testament to the fact that objects can and do resist."

—Fred Moten[1]

Let's start with a kiss.

We begin this history with an act of Black love. In particular, we begin with the kiss between Bahamian American performer and recording artist Bert Williams and performer and Harlem entrepreneur Odessa Warren Grey that takes place at the end of the 1913 American black-and-white silent film *Lime Kiln Field Day*.[2]

The story of memetic Blackness, the copying and transmission of Blackness-as-memetic-material—the Black meme, for which this book is named—cannot start without discussion of *Lime Kiln Field Day*, which is now widely reputed to be the oldest surviving film featuring Black actors.[3] Black love will carry us as we start: the kiss between Williams and Grey is a rare moment of intimacy between two Black actors, deeply unusual for this period.

It also shows Williams in blackface, a mark of the convention of the time requiring that, on screen and stage alike, Black characters be performed by actors wearing the minstrel makeup—even if the actors themselves were Black.[4] Williams's wearing of blackface was for him more than mere convention, however, for it provided him with a mask that stood strategically between him and the world. This created a bamboozling, perhaps farcical protective shield that, despite its link to a troubled and racist American history, allowed him to continue

to rise within his industry: at this time, Williams was one of the most famous Black performers of the 1900s.

Over a century later, *Lime Kiln Field Day* features prominently in artist and filmmaker Garrett Bradley's 2019 film *America*.[5] Bradley reflects on her own film as it engages these complex histories:

> What I loved about watching Bert Williams's *Lime Kiln Club Field Day* … was witnessing an early example of an integrated effort in support of a Black vision. This is part of what made the film so special and I think propels us even now, as individuals, communities, and institutions, 107 years later.[6]

The film's rushes were only found in 1939, by the first film curator of New York's Museum of Modern Art (MoMA), Iris Barry, among a larger institutional acquisition of 900 negatives from the trailblazing Bronx-based Biograph Studios in the wake of the closure of the studio's facilities. In the 1970s the rushes were transferred to safety film stock, and in the 1980s MoMA began the process of their restoration, but it was not until 2004 that MoMA film curator Ron Magliozzi began putting together the various components of the restored materials. Years later, Magliozzi spoke about *Lime Kiln Field Day*, saying, "I would like it to go viral."

Magliozzi imagines a particular sort of distributed future for this footage, explaining, "We [the MoMA] would like to give it back to the community, the [B]lack artists. [As a curator] I had a vision of giving it to important [B]lack artists and have them edit it, and sample from it, and do whatever they want to it."[7] Here, Magliozzi draws us into the tensions of, on the one hand, a sort of fantasy of cultural reparations—a "giving" of privatized, institutionalized, archival material "back" to a Black creative community—and, on the other, a deployment of the language of meme culture in a hope for the eventual virality of this early record of Black film.

4

With *Lime Kiln Field Day* owned by MoMA, and under the custodial care of a White, male curator, Magliozzi's dream of virality does little to resist the American tradition of White institutional gatekeepers' control over the transmission of Black cultural production, and their establishment of themselves as the ones who decide who should (and, in turn, who should not be) canonized as an "important [B]lack artist." In this way, Magliozzi bends history, bringing the labor of an early record of Black embodiment—a genesis story of Black movement within Black visual culture—to meet the fractal and rhizomatic transmission of this material. This is achieved via the vehicle of memetic transfer, complicating the authenticity of the material's agency from the vantage point of the present.

It is a fortunate turn of history, then, that an artist such as Bradley is among the first to carefully undertake this urgent and essential work of considering the ways in which *Lime Kiln Field Day* can travel into the world as empowered Black data. Her *America* intersperses twelve short black-and-white films with the "found footage" featuring Williams and Grey. Bradley speaks about her engagement with *Lime Kiln Field Day* in her own film using the language of the internet: as "algorithm[ic]" work.[8] Accordingly, this work sets out the ways in which these two films, now forever bound together, can help to reprogram visual culture, giving us new ways of seeing. It also provides a new genesis story for the birth of the moving image in America itself. Bradley explains:

> If I titled the work something so large, I ran the risk of being embarrassed—I'd certainly thought about that quite a bit—but I was willing to take that chance if it meant that when someone Googled "America," new images could pop up. That's why I think about it as, hopefully, an extended project that many people can create in their own iterations, in their own way, and repopulate the algorithm.[9]

Bradley's work as a filmmaker to "repopulate the algorithm" is a worthy and ambitious task when we consider what *America*, a radical imaginary—and even a judicious counternarrative, is up against amid the broader undertow of American visual culture.

One film, in particular, acts as the root of this American way of seeing. The cultural and social "text" of D. W. Griffith's silent epic *The Birth of a Nation*, made two years after *Lime Kiln Field Day* in 1915, is both undertow and riptide. It is a dramatization of the history of the Civil War in America that offers, through words and images, the foundations of a now-universal feature of contemporary online life: the GIF image format as we know it today. Griffith's film was "post-truth" (or, as theorist Hannah Arendt might have called it, a form of "defactualization") before the term became popular.[10] The work itself advances a virulently racist agenda at the birth of American cinema, while constructing a visual national story.

Griffith's film was directed during his time at Biograph Studios, the same studio that produced *Lime Kiln Field Day*. However, the studio was closed in 1915, prompted by Griffith's departure—a demonstration of his power in the industry during this period. That same year, *The Birth of a Nation* was screened at the White House, courtesy of then President Woodrow Wilson, and was only the second film ever shown at the presidential residence. It was lauded by Wilson as "like writing history with lightning."[11]

The Birth of a Nation is a key example of both the transmission of a counterfactual representation of Black movement and gesture, made minstrel in its racist performance of White actors in blackface, and the strategic application of a minstrel Black embodiment as a tool of political propaganda. The film itself—cited as a recruiting tool for the Ku Klux Klan—has been a fixture of cinema studies syllabi as an early example of filmic praxis.[12] At the same time, as film critic Richard Brody writes, *Birth of a Nation* is "the kinetic model for a century of action

scenes."[13] It has therefore become the original sin of American cinema, both in form and meaning. As producer Steven Jay Schneider notes, the film "introduced the use of dramatic close-ups, tracking shots, and other expressive camera movements; parallel action sequences, crosscutting, and other editing techniques" that established a precedent for much of Hollywood cinema—as well as internet-age mass media that draw upon it, including today's widely circulated "reaction" GIFs.[14]

These GIFs as moving images, now ubiquitous as stickers in text messages, social media posts, and online forum discussions, often depict well-known TV or film characters and their reactions or responses—ranging from exasperation, enthusiasm, or amazement—as drawn from originating sources. They regularly feature Black performers, so much so that "Black reaction GIFs" is a searchable category in and of itself on the GIF search engine Giphy. In a twist of fate, the failure of the original copyright holder to renew *Birth of a Nation* resulted in its fall into the public domain. This meant that anyone could duplicate and sell copies of the film, amplifying its virality. In 2015 critic and *Time* editor Richard Corliss wrote for the magazine: "Griffith's film is estimated to have earned $18 million in its first few years—the astounding equivalent of $1.8 billion today. In current dollars, only director James Cameron's blockbusters *Avatar* and *Titanic* have earned more worldwide."[15] Furthermore, *Birth of a Nation* shows us the ways in which the so-called Away From Keyboard (AFK) world has been shaped as a reflection of what we see on our screens (computer screens and movie screens alike, machinic kin). Conversely, Griffith's film demonstrates how what we see on our screens holds a mirror up to the flawed world around us.

We can see an example of this in the rise of the "Karen" meme, a moniker used, in the words of one journalist, as "a stand-in for problematic White women ... who commit acts in public that are perceived to be racist, such as unjustly calling the police on Black people."[16] The "Karen" exemplifies the ways in which White womanhood has been deployed as an

agent to reproduce and uphold the raced, classed, and gendered structures of patriarchy and its maintenance, that harks directly back to antebellum attitudes. In May 2020 a viral video circulated of "Central Park Karen," in which Amy Cooper, a White portfolio manager at an investment firm, makes a 911 call to report on Black birdwatcher Chris Cooper.[17] This damsel-in-distress move is pulled directly from an American visual culture playbook dating back to Griffith's *Birth of a Nation*, pathologizing the relations between Black men and White women in painting Black masculinity as a threat to the sanctity of White femmehood.

Thus, online/AFK comprise a loop reflective of structures that did not begin with the internet. Rather, the internet has only accelerated a preexisting link, making it faster and easier for the visuality of race, class, gender, and beyond to move between localities and publics, both on- and offline. For this reason, it becomes important here to recognize that the Black meme acts as both a trope and a trap. This troubled relationship is as much about the *transmission of Blackness* as it is about the sight and *viewership of Whiteness*. The tension here is therefore inescapably compounded and complicated.

The Black meme often includes images of Black people as subjects of extreme violence or, conversely, as entertainers who perform their material within an economy of White spectatorship. While this usually takes place without Black consent or compensation, it nonetheless feeds into the pervasive and perplexing fetishization of Blackness as a signifying jewel of otherness or alterity—as culturally ascendant hypewear.

In 2018, nineteen-year-old Swedish model and Instagram star Emma Hallberg gained attention for sharing photos of herself with her over 260,000 followers in what appeared to be blackface. Criticism was as swift as it was warranted. In response, writer Wanna Thompson tweeted on the topic of "[W]hite girls cosplaying as [B]lack women on Instagram," subsequently writing a piece for *Paper Magazine* titled "How

White Women on Instagram Are Profiting off Black Women," in which she further interrogates the phenomenon of "blackfishing." Blackfishing—when non-Black people pretend to be Black on social media utilizing a combination of makeup, prosthetics, and even surgery to amplify the performance—is a rising constant, seen across a myriad of social media influencers.[18] "I do not see myself as anything else than [W]hite," Hallberg told *Buzzfeed* in her defense.[19] "I get a deep tan naturally from the sun."

Conversely, as White womanhood dons Blackness, the platforms have included apps and filters to alter skin tone at will—a machinic play that offers a new twist to the legacy of colorism. Dawn Richard, star of girl group Danity Kane and a Black woman, said of Instagram filters in a 2013 tweet: "Filter is the new bleach. I mean it's cheaper tho I guess."[20] In 2014, writer Doreen St. Felix summed up this bizarre dilemma in a tweet of her own: "Everybody wanna be a [B]lack woman but nobody wanna be a [B]lack woman."[21]

Thompson's tweet and subsequent article came nearly a year after writer Lauren Michele Jackson penned a 2017 op-ed for *Teen Vogue*.[22] In her piece, "We Need to Talk about Digital Blackface in Reaction GIFs," Jackson defines "digital blackface" as a type of "minstrel performance … in cyberspace." Jackson had written on the topic first in 2014 in a piece for the *Awl*, where she wondered, "What is the half-life of a meme? What is the rate at which a good-natured meme decays into the grossest displays [of] public ridicule?"[23]

The viral circulation of the Black body in the form of reaction GIFs—Drake caught in an eternal shoulder-shake as he dances silently to his 2016 hit song "Hotline Bling"; actress Viola Davis as *How to Get Away with Murder*'s Annalise Keating taking off her wig and makeup; *Scandal*'s Kerry Washington as the fixer character Olivia Pope sipping wryly from her wine glass—lives as an archive of Black performance. The platform Giphy has become a monumental archive to Black movement, a living

theater of actions on eternal silent loop, dutifully performing for an audience of millions.

Black reaction GIFs provide a container for the holding and control of Black affect—one that performs and circulates without permission of, or payment to, those depicted within them. Fordist in their production and mass consumption, this digital material disassociates the Black body from a living, breathing selfhood and makes the Blackness within it a caricature, a cartoon. Poet Harmony Holiday, in her 2020 digital project and lyric essay "The Black Catatonic Scream," provides a call to action that is resonant and useful here: "Now we have to learn to listen to the speechless ruins."[24] In her essay, Holiday expands on the ways in which Black GIFs archive Black gesture and hold it captive:

> GIF/glyph is the defiant nature of Black speech and Black movement isolated and objectified and then amplified until it becomes an autonomous symbol of some nameless but omniscient rebellion enacted on the hyper-policed terrain of the mundane, and immortalized in suspended animation like a poem whose rhyme makes it impossible to lose or forget. This quotidian debris helps us decode the Black subconscious and isolate with intention, so that we no longer have the luxury of overlooking subversive inklings; nothing is covert anymore. Our catatonia has turned on itself, speaks in pictographic tongues and places us in a collective trance. We regain our command of this grammar by learning to embody it. In so doing we overcome the false glamour of speechlessness with the interminable thrill of insinuation. And we commune and communicate like hostages whose ransom will be naming and identifying our clandestine body language.

What Holiday dubs a "memetic emancipation" is urgent.[25] It is perhaps a necessary step toward memetic reparation. Both Jackson's and Holiday's proposals expand our understanding

of what it might mean to "get free," as we continue in the work of abolition.[26]

Holiday frames the material of GIFs as a way of speaking. It becomes an utterance that, by its looping repetition, embeds a glitch. To call on the words of curator Meg Onli in her groundbreaking *Speech/Acts*, "The instability in the definition of [B]lackness" performs as a demand, erratum, and intervention.[27] This occurs alongside the pushing back against—as American Artist puts it in their essay on the virality of rapper Bobby Shmurda, originator of the popular #ShmoneyDance—"the disparity between this level of visibility and its financial pay-off."[28]

What the Black meme shows us as it unfolds is that being *seen* and *consumed* does not correlate with being compensated. This is why here, together, we wonder: *How can we let all these memes—all these versions of Black selfdom, held captive— scream? What does a memetic "Black Chant" as a refusal of, and resistance against, digital blackface look like?*[29] The chapters of this book are the Black chant and curious incantation.

Blackfishing and digital blackface go hand in hand, each bending to the other. The presence of this dual phenomena gestures toward the enduring legacy of minstrel shows, a theatrical tradition of blackface that finds its root as early as the nineteenth century. Whether it is Emma Hallberg or the infamously self-determined "trans-Black" American academic and activist Rachel Dolezal, a self "Blackened" in body or affect is one for capture. It is a body that, when donned, gives the wearer the permission to perform. This performance itself triggers a mandatory becoming.

In this book I argue that Blackness *in itself* is memetic and, by extension, that the technology of memes as a core component of a dawning digital culture has been driven by, shaped by, authored by, Blackness. The transmission of material such as reaction GIFs and images of social media influencers painted head to toe in Black(ened) skin tones demonstrates the complicated power drawn from, and troubling racialized agenda

triggered by, the performance of Black embodiment. Regardless of this complexity, it is very clear: digital culture—and the visual culture that carries it—does not exist without Black people. As media scholar Charlton McIlwain aptly puts it: "Black people and Black content and Black cultural production was really at the core of what became the internet as we know it today."[30]

Across the eleven sections that follow, *Black Meme* identifies critical turning points across an American history of media and visual culture that have paved the way for the notion of the "meme" as we understand it today. Beginning in the 1900s and traveling through to the twenty-first century, this history explores the construction of digital virality. These moments are significant because, while they show us that Black virality predates cyberspace and the networked internet as we now know it, they also instruct us toward a history of Blackness that has made possible the advancement of such technologies themselves.

This relationship is symbiotic. Committed to the care and collectivity of this work, I want to recognize, as we dive in together, that the stops on this journey present only a small cut of the vast constellation of material that has informed these histories. Given the expansiveness of the Black diaspora, I have deemed it prudent to limit the examples provided here to the US context. Nevertheless, these images have meaning beyond these borders. Thus, the analysis here can be charted on a local, national, and international scale. Memetic Blackness is not an *American dilemma*; it is a global trouble. As such, responsibility for it must be internationally intersectional. Therefore, as we grow together into the future of visual culture, a collective global effort will continue to be significant and undoubtedly cumulative, informing this dialogue further.

With this in mind, *Black Meme* as a book is by no means meant to be a comprehensive "history of …"; indeed, the text rejects such flattened and didactic synopses as acts of violence in and of themselves. Rather, it attempts to suss out how the language of "meme" and "viral" has a clear and direct confluence

with the presence of a networked, "distributed" Blackness—one with which we continue to grapple.[31] The hope, then, is that this book, in exploring the impact of Blackness, Black life, and Black social death on contemporary conceptions of virality born in the internet age, will drop a necessary pin, giving us pause. By complicating the fractured histories of the "Black meme," showing us where this material has come from and what it can do, perhaps this examination can help us strategize on how—as critic Terence Trouillot wrote about artist Sondra Perry's seismic 2012 solo exhibition *Resident Evil*—"to give agency to the [B]lack meme, imbuing it with a radical purpose: a virus that no longer infects just the Internet, but physical space—bringing more [B]lacks into [W]hite schools, [W]hite galleries, and [W]hite homes."[32]

As we advance, let us define some terms: "meme" is an abbreviated form of the Greek word *mimeme*, which means "something imitated." This book defines "Black meme" through the notion of "transmission," quite literally *the mediation, copying, and carrying of Blackness itself as a viral agent*. This is buoyed forth by modern media, such as (but not solely) the internet, and the wider engine of visual culture.

Predating the 1900s, one could argue that the first Black memes were those transmitted via the Middle Passage. The transfer of the "Black meme" as a material comes down to the movement of Black data as carried by Black people, carried first in the form of our physical bodies. This caused a rupture in Black speech, gesture, movement, embodiment that was then co-opted by the violent project of American capitalism. This is made literal when we cross-reference illustrations of the transatlantic slave trade routes against the charting of transatlantic cable routing that makes possible today's "wireless and satellite technologies"; eerily, they follow similar pathways. These data visualizations show us that in the place of *people's information*, embedded in the Black bodies held by the ships' holds, now travels the *packet information* of Black people, the

cultural and social information and knowledge authored by Blackness. This historical legacy of transmission is staggering, yet long overdue for wider recognition.

Artist Tabita Rezaire has done important work to excavate these histories. In the accompanying text for Rezaire's 2017 exhibition *Exotic Trade*, the artist unpacks this:[33]

> The ocean is home to a complex set of communication networks. As modern information and communication technologies (ICT) become omnipresent in Western lifestyles—rebranded global to further implement Western domination—we urgently need to understand the cultural, political and environmental forces that have shaped them. Looking at the infrastructure of submarine fibre optic cables that carries and transfers our digital data, it is striking to realize that the cables are layered onto colonial shipping routes. Once again the bottom of the sea becomes the interface of painful yet celebrated advancements masking the violent deeds of modernity.[34]

In response to such violence, including the transmission of the Black meme, we must also consider the concept of "data healing," as theorized by guerrilla theorist and curator Neema Githere.[35] Githere proposes a counterpoint to "data trauma," a term coined by media artist and programmer Olivia McKayla Ross. Data trauma "describe[s] the compounded effects of navigating digital infrastructures created to exploit, categorize, and discard personhood."[36] For Black people online, existing between these two points has disturbingly become a natural state of being. Thus "data healing" is a call-and-response to the "data trauma" that can be transmitted epigenetically across digital generations, an opportunity to reflect forward as to what work can undo the effects of having one's physical and social death played back in digital minstrelsy in a never-ending loop.

It is a short leap to arrive at the conclusion that part of the "digital weathering" triggered by data trauma is due to the

active displacement, theft, and erasure of Black contributions to digital culture.[37] This can be defined as a networked expansion of the term "weathering," first coined by American public health researcher and professor Arline Geronimus in discussion of disparities of health for Black mothers and infants, a "deteriorat[ion] in early adulthood as a physical consequence of cumulative socioeconomic disadvantage."[38]

This is set against the "digital John Henryism"—another neologism, first applied here to illustrate and historicize the impact of the hypervisibility, circulation, and consumption of Blackness in digitally networked spaces.[39] This hypervisibility, though persistent, does not always lead to care-full representation, recognition for contributions made, or corrections produced to rectify the built-in supremacies surfaced via the logic of algorithmic bias in the material Black data that, in its networked transmission, "goes viral."

Artist Hito Steyerl keeps giving the truth we need:

> One cannot understand reality without understanding cinema, photography, 3D modeling, animation, or other forms of moving or still image. The world is imbued with the shrapnel of former images ... Reality itself is postproduced and scripted, affect rendered as after-effect. Far from being opposites across an unbridgeable chasm, image and world are in many cases just versions of each other ... This assigns a new role to image production, and in consequence also to people who deal with it.[40]

"Deal[ing] with it" becomes, then, its own economy within viral communication, informatics, and the oft-invisible labor of data dissemination as it is farmed and manufactured. We see the "after-effect" of reality production that Steyerl cautions in everything from content moderation as it occurs across all online platforms, to the rise of "non-playable character" performance on TikTok by content creators such as the Montreal-based Black influencer Pinkydoll, who has been

accused of gaming TikTok's racialized and colorist algorithm by presenting herself as light-skinned to accelerate her traction and appeal.[41] Through this frame, reality itself has become a "poor image." In Steyerl's 2009 essay "In Defense of the Poor Image," the artist observes:

> The poor image is a copy in motion. Its quality is bad, its resolution substandard. As it accelerates, it deteriorates. It is a ghost of an image, a preview, a thumbnail, an errant idea, an itinerant image distributed for free, squeezed through slow digital connections, compressed, reproduced, ripped, remixed, as well as copied and pasted into other channels of distribution.[42]

Artist, curator, and critic Aria Dean expands on Steyerl in her 2016 essay "Rich Meme, Poor Meme" by saying the loud part out loud: "Blackness, as poor image, as meme, is a copy without an original."[43] To extend outward from here, I take as a starting point for this book that Blackness, always existing in transfer and transmission, is the originating cultural engine and the machine.

This book centers codependent questions of responsibility and accountability within the transmission of Blackness as an agent. It thinks through the ways in which the work of "Black memes" can perhaps labor differently. It makes it indelible that memes are not neutral, nor are they passive subjects. Rather, it raises legal, ethical, moral, social, and cultural questions about subjectivity, personhood, and the ever-complicated fault lines of race, class, and gender performed both on- and offline.

Black Meme takes on the economy and engine of this, holding space for those who have done important work to advance this conversation and furthering a discussion about how we can hold ourselves accountable for the ways this material is produced, circulated, bought, and sold.

1

STRANGE FRUIT, GONE VIRAL:
THE SOULS OF MOVING IMAGE

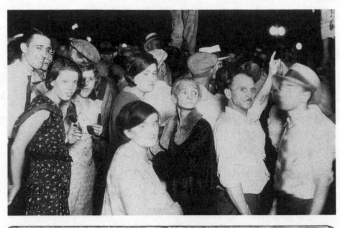

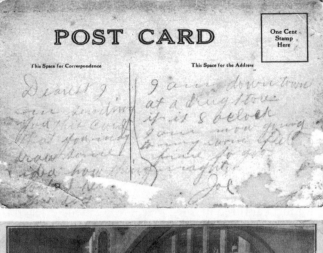

POST CARD

One Cent
Stamp
Here

This Space for Correspondence | This Space for the Address

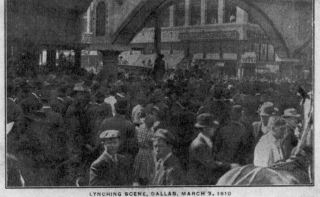

LYNCHING SCENE, DALLAS, MARCH 3, 1910

"Went looking for the art and we were the art."

—Glenn Ligon[1]

The Black meme could not have been possible without the devastating American history of lynching photography—the practice of producing and circulating postcards as souvenirs of the lynching of Black people. What is mutually horrifying and remarkable is that these images not only show the bodies of Black victims but also often foreground the gatherings of White people that turn the crime into a communal event. These postcards shamelessly reveal that lynching was a spectator sport and recreational spectacle. The White audience that congregated in public saw these moments as a social activity and did so both to witness and to delight. In many, the crowd is celebrating, often smiling, sharing in their victory.

Photographs of this variety made it possible for this genre of terrorism to travel via mail across state lines. Such images were not just captured in one place. Nor was their distribution restricted to one region of the world. In fact, there is plenty of evidence of their international circulation. The postcards function as a form of telegram, urgently sharing the news. They established a genus of visual reportage that, once seen, could not be unseen and performed an active flex on behalf of White supremacy.

The lynching postcard is an alternate original sin to America's visual culture. Preceding the rise of D. W. Griffith's landmark silent film *Birth of a Nation* but continuing concurrently alongside it, this type of circulated media—souvenirs of hate crimes—is imprinted on our cultural consciousness and is

fundamental to the idea of the Black meme. Indeed, these images shaped the notion of memetic or viral imagery.

Often accompanied by a poem or lines of text, late-nineteenth-century lynching postcards were a nascent form of moving image—Black images that moved with a designated selection of words via manual transmission as they were bought and sold, sent and received. The distribution of "matter of a character tending to incite arson, murder, or assassination" through the US mail was banned in 1908, as an amendment to the 1873 Comstock Act.[2] Despite this, lynching postcards continued in their circulation via the mail and other channels throughout the twentieth century, as the practice of organized, racially motivated murder continued across America. In 2015, the Equal Justice Initiative issued a report of 4,400 documented lynchings of Black people in America between 1877 and 1950.[3] In the report the Initiative explains that "public spectacle lynchings were attended by the entire [W]hite community and conducted as celebratory acts of racial control and domination."[4]

Photographer Lawrence Henry Beitler captured one of the most famous images of this period, the lynching of two young Black teenagers: Thomas Shipp, eighteen, and Abram Smith, nineteen, in Marion, Indiana, on August 7, 1930. A mob of 12,000 to 15,000 people was said to have gathered to watch the young men beaten and hanged in the square, where the bodies were left suspended for hours.[5] White townsfolk came to socialize under the bodies, and to take pictures. Forty-four-year-old Beitler, who often photographed local weddings and church groups, was among the crowd; with him he carried his eight-by-ten-inch camera, a tripod, and flash powder.[6]

The image is haunting: it depicts a crowd of White people; among them a couple holding hands, a pregnant woman, and a woman wearing what appears to be a fur stole. Many of them are looking directly at the camera while over them float the bodies of Shipp and Smith. In the center of the photo a mustached man extends an arm to point at the bodies as he

unflinchingly confronts Beitler's gaze. "Pointers" were common for this genre of photography, articulating the visual threat to Black people to remain fixed in, and with active adherence to, their social and cultural subservience, or risk being maimed or murdered themselves.[7]

Once processed and put on sale for the price of fifty cents, orders for the photo poured in. To meet the demand for the prints, Beitler worked around the clock for ten days straight. In 1988 Beitler's daughter Betty told the *Marion Chronicle-Tribune*, "It wasn't unusual for one person to order a thousand at a time."[8] Today, a Getty Images search for "lynching" yields 1,822 images. Beitler's image appears as the "most popular" hit, the standard editorial rights of which can be purchased at $175.00 for a small print, $375 for a medium print, and $499 for a large print.[9]

The late American civil rights activist James Cameron, who as a teenager had narrowly escaped the same fate that August night in 1930, reflected on his experience:

> I stood there in the midst of thousands of people, and as I looked at the mob round me I thought I was in a room, a large room where a photographer had strips of film negatives hanging from the walls to dry. I couldn't tell whether the images on the film were [W]hite or [B]lack, they were simply mobsters captured on film surrounding me everywhere I looked ... [After a] brief eternity ... the roomful of negatives disappeared ... I found myself looking into the faces of people who had been flat images only a moment ago ... I could feel the hands that had unmercifully beaten me remove the rope from around my neck. I suddenly found myself standing alone, under the death tree—mystified![10]

Cameron's description of his presence in the mob, "in the midst of thousands," is remarkable, as he describes the way in which he processed this moment of trauma as if looking at "strips of film negatives."

Through this incisive narration, Cameron reveals a complex collision of memory, driven by his lived experience, with the material of the moving image itself. His way of making sense of the event is articulated via what has since been called the "new aesthetic" of filmic technology.[11] There is a machinic convergence between the body and the material of the moving image, where a Black person experiences their own selfhood as if watching a film of their own lived trauma. This is a form of disassociation that evinces how viral images of Blackness, as they circulate, shape-shift and transform the way Black people process their own pain, mediated by the technologies and visual cultures we are immersed within and exposed to over time.

Media scholar Henry Jenkins speaks to this in the terms of "convergence culture," a phenomenon he defines as "where old and new media collide."[12] What Cameron then tracks for us is the way in which Blackness—mediated by technology itself—becomes a dissociative experience of *watching oneself from the outside*, while at the same time *living inside of oneself*. This convergent viewership of the scene, simultaneously as "producer" and "consumer," situates him at the tender and complicated intersection of what American sociologist W. E. B. Du Bois called "double-consciousness." In 1897 DuBois wrote for the *Atlantic*: "It is a peculiar sensation, this double-consciousness, this sense of always looking at one's self through the eyes of others, of measuring one's soul by the tape of a world that looks on in amused contempt and pity."[13]

We can consider, then, that Cameron—born in 1914, the year after Bert Williams's film *Lime Kiln Field Day* found its way into gorgeous being—encountered in real time the presence of lynching photography. Beitler's image then becomes an anti-portrait of Cameron himself, a document of death that serves as an enduring reminder of the impossibility of Cameron's survival.

Lynching postcards are a form of moving image that blurs the dawning history of cinema and a digitally networked culture

that predates the internet.[14] These postcards were transformed into viral imagery in four stages: first, via their production; second, via their popular and widespread distribution as they were sent into the world; third, as they were received (which raises important questions of consent, to which we will return); and, fourth and finally, as they were (and are) kept, maintained, and returned to.

A fifth stage emerges contemporaneously with the rise of viral material as it intersects with the networked media, reportage, and communication of today: the internet's recirculation of these materials. This is a memetic transfer so vast in its form, scale, and speed that it would have appeared to be magic, unimaginable to the likes of Beitler in the 1930s. As these images enter into the "public domain" of cyberspace, they transform our understanding of their locality, through and beyond both our collective and individuated imagination. They also transform and unsettle how we conceive of *public* versus *private* as social, cultural, and even legal infrastructure. The ongoing circulation of lynching postcards and photography is a perpetuation of a crime, the murderous acts now interminable as they move into every corner of the digital. The subjects seen in these "windows" travel devoid of any agreement; they are now public property. Given their history, the ongoing transmission of lynching postcards triggers a private domain as a Whitened counterenclave within public viewership, extending their supremacist logic into the twenty-first century.[15]

The rise of new visual economies and new modes of transmission means that the internet creates new private spaces, hidden in plain sight. Historian Hayden White observes, "The problem now ... is how we re-imagine history outside of the categories that we inherited from the nineteenth century."[16] Thus, the questions we must ask are not simply historical; they're structural. As screen studies scholar Patricia Zimmerman reminds us: "The public domain is not one entity, but many."[17]

With these structural inquiries at the fore, we must continue

to bridge between "old and new media" to best identify the opportunities for intervention. Though the first GIF moving image did not emerge until 1987, the definition of a "Graphics Interchange Format" as a "set of frames [crammed] into a single file for sequential playback" vivifies the violence of lynching photography and postcards.[18] It is a mutated zoetropic stop-motion in playback that, to call on a term of theorist and critic Sianne Ngai, exposes the "racialized animatedness" of the medium as a "racializing technology."[19] In short, lynching postcards are reaction GIFs: reactions of White spectacle as activated by the shared intimacy of Black death. If we consider these paper-based print materials as "strips of film negatives" themselves, they become the visual blueprint for motion pictures such as Griffith's *Birth of A Nation*, setting a painful precedent for the kind of media we will explore as we advance together here.

As described by writer and professor Amy Louise Wood, the postcards were, in their moment of creation, "intensely local and personal"; yet once "removed from their localities," all this changed. The supremacy of their intent became the core driver of their application: they did not record an event but became a viral advertisement for violence. Despite the intention, however, within the moment of their production, their "meanings became quite unstable"; their production allowed anti-lynching activists to imprint, quite successfully, entirely different meanings upon them.[20] This is noteworthy, given that the "imprint" of new meaning by activists against lynching reverses the movement from local to universal. Instead, these activists reinstated the specificity of the location of viral material: *it happened here*. At the same time, this elision erodes any assumption of a shared experience of viewership when engaging with these raced technologies.

This volatility and instability of the image, as illustrated here, makes the material of the Black meme even more important to consider with slowness. It is essential to underscore that the

resonance of its impact will inevitably be informed by the lived experience of the receiver as much as driven by the intent of the sender. Still, in the internet age, these postcards remain coveted collector's items for some and, as seen with Getty Images, have entered an online archive and memorabilia marketplace. This is reflected in the myriad of "rare lynching photo postcards" up for auction on websites like eBay, categorized as "Collectible Black Americana."

At this writing, a first result for the eBay search "lynching postcard" is "Postcard—Rare March 3, 1910 Lynching Scene in Dallas TX," with a "current bid" of seventy-six dollars.[21] The image shown in preview is of a crowd, all facing away from the photographer, looking on at the contour of a Black body in the distance, suspended from an archway. This is a painful document of the lynching of Allen Brooks, a Dallas handyman who, while awaiting trial, had a rope placed around his neck and was pulled by an angry mob from the second-story window of the courthouse. Brooks was dragged to the Elks Arch, a landmark in downtown Dallas, where he was suspended from a telephone pole in front of an audience of thousands. Members of the public who attended cut pieces of his shirt to take away as souvenirs. The presiding judge concluded in court records: "Case dismissed."[22] Postcards featuring an image taken by an anonymous photographer were printed en masse. In the postcard image, only two figures meet the "eye" of the camera, both of whom appear to be young White men, their stony facial expressions illegible. On its verso, a casual message written in a loose scrawl begins: "Dearest," and then a few lines later, "I am downtown at the drugstore."

The violence of this quotidian usage is seismic: a site of Black death becomes the banal medium for an intimate epistle. Equally devastating is the online sale of such postcards. This horrific juxtaposition cannot be overlooked: over 150 years after the abolition of slavery, images of Black bodies continue to be auctioned to the highest bidder. The heraldic legacy and

fetishization of Black-death-as-meme continues to reverberate: the memetic transmission of social and corporeal death, both significant triggers to a durational epigenetic "data trauma" for Black people, to recall Olivia McKayla Ross's terminology.

In 1976, the photographer Cindy Sherman was twenty-two years old and a recent graduate from SUNY Buffalo State.[23] That year, Sherman began a series of self-portraits titled *Bus Riders* (1976–2000), which featured the artist in what has now become her signature style of "enacting others," performing different personalities—Black and White alike—that she imagined might be encountered on a public bus.[24] As part of this series, Sherman represents herself in blackface, transforming into an embodied caricature of Blackness that, with a toothy grin, harks back to the dawn of American minstrel entertainment.

In a 2005 *New York Times* review of the late curator and art historian Maurice Berger's exhibition at New York City's International Center of Photography, writer Margo Jefferson noted of the images' subjects:

> They are male and female, young and aging; they are street kids, workers and yuppies. But the [B]lacks are all exactly the same color, the color of traditional blackface makeup. They all have nearly the same features, too, while Ms. Sherman is able to give the White characters she impersonates a real range of skin tones and facial features. This didn't look like irony to me. It looked like a stale visual myth that was still in good working order.[25]

Jefferson's disappointment underscores the resurrection and re/application of "visual myth" as a troubled dynamic of these images, not only in their making but also in their exhibition. Here, she points toward what the *act of looking* does to perpetuate the violence of Black mythos—how consumption of an image begins so often with what the late critic and essayist

John Berger termed "ways of seeing," the strategies of how we look, and how these things perpetuate the biases we carry. These sight lines are further dictated by the enactment of Blackness *by* Whiteness: the understanding that a Black body, for Whiteness, will always be a vacant costume to step into as a skin and re/perform memetically at will and whimsy. Artist E. Jane, who led the 2015 social media campaign of #CindyGate to call attention to the troubles of Sherman's participation in, and production of, these images, observes:

> I think Cindy Sherman, in showing those ill-conceived images, represents her own oppressive thoughts, which maybe Black publics don't need to see ... I think what would be the least harmful would be to not show the work and instead show a quote from her explaining that she once made racist art and acknowledges that it was wrong, since it must be accounted for in a retrospective. I don't think the project's existence should be hidden, but I also don't think the work itself should be shown.[26]

Perhaps, then, this makes Sherman a godmother of blackfishing. Her creation of the blackface "selfie" images augurs the machinic technologies aided by the visual distortions of filters later made widely available via digital platforms and social media.

Black feminist theorist and professor of visual culture Tina M. Campt pushes back on the extraction of sight as a means of redressing the "precari[ty] and dispossess[ion of] [B]lack subjects in the nineteenth, twentieth, and twenty-first centuries," encouraging a viewer's "attend[ance] to the quiet but resonant frequencies of images that have been historically dismissed and disregarded." Campt writes,

> Refocusing our attention on ... sonic and haptic frequencies on the grammar of [B]lack fugitivity and refusal that they enact reveals the expressiveness of quiet, the generative dimensions

of stasis, the quotidian reclamations of interiority, dignity, and refusal marshaled by [B]lack subjects in their persistent striving for futurity.[27]

Campt's proposal of *listening to images* is an act of radical decolonization that pushes back at the wayward strategies of colonized sight, a key to data healing within the complicated histories of photographic image-making of (and taking—with, from) Black people. Because of this, it feels important to consider the ways in which re/performed, transferred, transmitted memetic Blackness presents a sonic experience of static hiss at top volume, a droning psyop of noise that both disorients and distracts. This makes it challenging—but not impossible —to do the quiet work of listening and bearing care-full witness to the tender vulnerability of embodied Blackness. This dilemma illustrates why it is that so often within a conversation of equity, responsibility, and ethical stewardship of Black selfhood, the distinct and disparate strands of representation and visibility become entangled and confused.

Blackness, so vastly distributed, *appears to be everywhere*; this saturation of visibility via the cultural tradition of its dispersion bolsters the fiction of equity, making it difficult to visualize the dearth of real and sustainable models of representation. If Blackness has become an evolutionary technology and cultural skin, then it is so pervasive a memetic mutation that, as a mark of progress within the aesthetic of modernity, it has augmented American reality altogether. Here, Campt's *listening* as a goal and mantra continues to guide, as we circle to the question of *who is human* and the ways in which the taxonomy therein is shaped to exclude Black personhood, distilling Blackness to an aesthetic in lieu of a lived and sentient corporeal physicality.

In 1992, on the occasion of the LA uprisings following the brutal beating of Rodney King at the hands of the Los Angeles Police Department and the acquittal of those officers, theorist

Sylvia Wynter published the essay "No Humans Involved: An Open Letter to My Colleagues." As she writes, the LAPD strategically deployed the classification "No Humans Involved" (NHI) to flag incidents that resulted in the deaths of Black people, poor people, and sex workers, using it to excuse the officer's brutality. Writer Hannah Giorgis observes that the NHI classification "open[s] a horizon from which to spearhead the speech of a new frontier of knowledge to move us toward a new, correlated human species, and eco-systemic, ethic."[28] In her originating essay, Wynter points out that the taxonomy of NHI and the systems it lays out lead to "the misrecognition of human kinship ... as well as the systemic condemnation of all the Rodney Kings." She calls for a "mutation of knowledge" as a way of refusing the supremacist paradigm of knowledge-making.[29] The very presence of this category of "NHI" marks Blackness as a socioeconomic agent: to be read as human in America one must assume that you are not Black, that you are White, that you are wealthy, and that the labor in which you engage is state sanctioned (and/or not determined criminal by the state).[30]

In this way, Wynter gestures toward a deep-seated algorithmic failure. The NHI designation, in its very language, is a devastating expression of, to call on E. Jane's words, the "oppressive thoughts" of Whiteness. These, when set into motion, serially dictate and overdetermine the overamplification of precisely those violent systems that brought it into being in the first place. Essential here is the link between the language *heard* and the formation of a mode of becoming for what is *seen*. It means that when the state dictates what is and is not "human," it is a mode of exercising power over what is and is not visible, and thereby what can or cannot be voiced or heard.

The ephemera, or trace, of "no humans" as a disempowered and/or unconsenting Blackness operates in paradox: invisible and erased on the one side, and hypervisible as a memetic trope (and quite literally a transferrable outfit) on the other.

The circulation of lynching photography via the postcard made a *material engine* of Blackness, shaping it as both allegorical and decorative.

We can see an extension of this narrative in the 1979 exhibition at New York City's alternative gallery Artists Space of twenty-three-year-old White artist Donald Newman, titled *Nigger Drawings*, presented under the then directorship of Helene Winer. Newman (who went by the first-name moniker "Donald," but whom I intentionally refer to by his full name in these pages as a continued call to accountability) was described by art critic Rudolf Baranik as "young, White, punk and hungry for success."[31] In her *Whitewalling: Art, Race, and Protest in Three Acts*, writer and curator Aruna D'Souza reflects on the events that rose from the mounting of the show, aptly underscoring the exhibition's press release as "breathtakingly understated." It certainly was:

> Donald's "Nigger Drawings" are seven 5' x 7' triptychs combining black and white photography and charcoal drawing. This series of work was made between 1976 and 1978. The artist is currently engaged in making a series of larger color works.[32]

Plainly put, the title of Newman's drawings was never addressed in the promotional material. Instead, the language of the exhibition focused purely on its formal content: charcoal drawings that actively distorted and abstracted the photographic images they engaged.

The exhibition was protested by members of the Black Emergency Cultural Coalition, a group of Black artists first collectivized in 1969 to rally against the Metropolitan Museum of Art's *Harlem on My Mind* that same year, an exhibition about the neighborhood internationally known as a Black mecca that included no Black artists.[33] The BECC voiced their concern and rejection of Newman's show alongside other leaders of the Black arts community such as artist Linda Goode-Bryant,

founder of the avant-garde Black art space Just Above Midtown (1974–1986); then Met curator Lowery Stokes Sims; artist and then MoMA curator Howardena Pindell; and writer, critic, and curator Lucy Lippard; among others, Black and non-Black alike. Two protests were planned to be staged inside of the Artists Space gallery. While one took place, the second did not, because the gallery locked them out.[34]

Conversely, both Newman's work and Artists Space were vociferously defended by a star-studded coterie of art-worlders such as Laurie Anderson, Roberta Smith, Rosalind Krauss, and Douglas Crimp.[35] Together they wrote an open letter stating defensively that "this sensitive issue is being exploited by the Emergency Coalition, as a means of attracting attention." They went on to condemn the efforts against the show as "harassment" and "insensitiv[e] to the complexities of both esthetics and politics."[36] Winer noted that the artist "felt it had an esthetic complexity, it was metaphorical," observing, "I was surprised that everyone who was offended saw it only in the absolute, slur meaning."[37]

The focus, then, on Blackness as "metaphorical," or solely an "esthetic complexity," extends further this notion of the Black meme. It becomes a decorative material intended to be applied toward a purified artistic execution, to be transmitted without agency by Newman as a White artist. Notably, Newman had explained matter-of-factly to the *New York Times* that same year that apparently "none of his [B]lack friends objected to the title."[38]

In a bizarre twist, the photographer Cindy Sherman, at the time a recent transplant to New York, had been hired as a receptionist at Artists Space.[39] Sherman shared with Black artist Janet Henry that she objected to the show, but "when [she was] asked about the title, [Newman told her] that at the end of his drawing sessions Donald's arms were covered with black pigment, making him look like a 'nigger,' in his mind."[40]

In this, we see the materialization of Blackness as memetic

skin, made literal in the artist's body covered in charcoal, a minstrelsy by any other name. Winer was quoted in the *Village Voice* stating:

> At this point, "nigger" is a broadly used adjective that no longer simply refers to [B]lacks in a pejorative context. Artists refer to the projects gallery at the Whitney as the "nigger gallery" because it ain't the big time upstairs. People are neutralizing language. These words don't have quite the power they used to—and that seems like a healthy thing.[41]

Critical here is the emphasis on making "neutral" Blackness as a layered affect and material to be applied broadly, without responsibility, to Black people themselves: Wynter's "No Humans Involved" certainly rings clear in the splicing of Blackness from its involvement of human recognition, a complex algorithm, a broken code. To quote again W. E. B. Du Bois's 1921 postscript from his *Darkwater*: "I have been in the world, but not of it."[42]

In documentation of one of Newman's works from his exhibition, we see a triptych, a tree in the center frame.[43] Viewing this now, the tree is not just a tree, but a body in pain: we are transported back to Thomas Shipp and Abram Smith, the teenagers murdered by lynch mob in Indiana in 1930. This tree, one in a suite of drawings called by a hateful name, is a proxy to all the Black human bodies who have been subject to such violence, a triggering haunt of the White mob, all bound up inside alternative White art walls. Online today, one can purchase, via AbeBooks, Newman's exhibition announcement, "clean and unmarked as issued," for a price of $175.00.[44]

2

EATING THE OTHER: EMMETT TILL'S MEMORY, MYTH, AND BLACK MAGIC

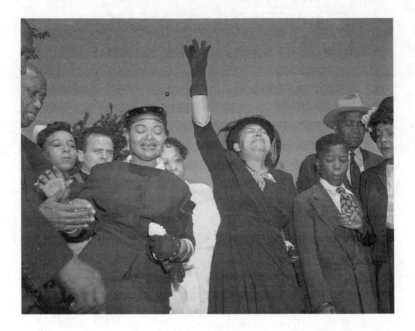

"I looked at the face very carefully. I looked at the ears, and the forehead, and the hairline, and also the hair; and I looked at the nose and the lips, and the chin. I just looked at it all over very thoroughly … And I knew definitely that it was my boy beyond a shadow of a doubt."

—Mamie Till-Mobley, on setting eyes
on her son when first identifying him[1]

"It was him but it was all of us."

—James Baldwin, on seeing
Emmett Till's body[2]

In 2022, the US House of Representatives passed a federal anti-lynching bill. Honoring the memory of a national tragedy, it was titled the Emmett Till Antilynching Act. Despite this call into recognition by naming the act after Till, that same year, a grand jury decided against indictment of Carolyn Bryant (who later took the name of Carolyn Bryant Donham, as she remarried), the White woman who, sixty-five years prior, had accused the Black fourteen-year-old of whistling at her. Reportedly, Bryant and Till first crossed paths at Bryant's Grocery and Meat Market, a store in Money, Mississippi, at that time owned by Carolyn Bryant and her then husband, Roy Bryant.

Drawing from a lineage that arcs backward to D. W. Griffith's vile representation of Black men as threats to the purity of White womanhood in *Birth of a Nation*, and forward to the exact construct of today's "Karen," Carolyn Bryant's accusation set off a brutal chain of events that remain to this very moment stripped of the delivery of justice.

On the night of Till's murder, Roy Bryant and his half brother J. W. Milam arrived at the home of Till's uncle Moses Wright in the night's cloak of darkness. Bryant and Milam, two full-grown White men, made the teenaged Till get dressed and took him away in their car. Days later, Till's disfigured body was pulled from the Tallahatchie River.

Protected by double jeopardy—an American form of jurisprudence that shielded them from being charged of the same crime twice—Roy Bryant and Milam spoke on the record of the murder in *Look* magazine in January 1956. The two men, described in the article as "poor: no car, no TV," accepted $4,000 for their interviews.[3] The only other document was the trial's transcript, the sole record of the original testimony, which was lost and then rediscovered in 2005. It was described by Robert J. Garrity Jr., an FBI special agent charged with investigations in Mississippi, as "a copy of a copy of a copy," the document itself memetically transfigured.[4]

In the document, Chester A. Miller, the Black undertaker, described what he saw as Till's body was pulled from the water:

> It was a dead body ... it was lying in a boat ... the boat was up on a bank ... there was a big wheel there ... [a] wheel and a strand of barbed wire ... it was right around the neck ... it [the body] wasn't clothed ... the flesh in the palm of the hand, well, it looked like the body of a young person.[5]

Miller had seen a gin fan wrapped around Till's neck with barbed wire. A gin fan—also known as a "cotton-gin" or "cotton engine"—is a heavy, large metal wheel that pulls apart cotton strands from their seeds. The transformation of this symbol of the project of Black exploitation under American capitalism into an instrument of physical torture reveals a twisted psyche that innovates technologically to support a status quo supremacy.

Later in the trial transcript, we witness the White C. A. Strickland, an "identification officer for the Collision Department,"

describe his documentation of "a dead body" at Miller's funeral home:

Q I now hand you a photograph and ask you to identify that and tell the court and jury what that is.

A That is a picture of the body that I photographed on the 31st of August, at about three p.m. in the afternoon. It was on a table at the back of the Century Burial Funeral Home there in Greenwood.

Q Now I will ask you whether or not this photograph represents the true situation that was there when you photographed that body?

A It does.

Q And you took it with what kind of photographic equipment?

A I used a 4 by 5 Crown graphic camera.

Q And is that the kind of camera you use normally in your work?

A Yes, Sir. I take the pictures, and develop them too. I took the pictures there, and I printed the film and developed it myself.[6]

Strickland's photographs of Till's body were then taken into evidence. However, the writing on the back of the photographs, and the separate photographs of the gin fan that Miller recounted as being lashed to Till's neck, were obstructively cited as irrelevant and struck from the record. The court concluded:

> The objection will be sustained as to the gin fan picture. The photograph of the body will be admitted providing what is written on the back of the photograph is marked out or obliterated so that it cannot be read or identified.[7]

These acts of redaction underscore the model of power and supremacy: the court as a White force capable of deciding

what should and should not be seen for the rest of history. Strickland's description of his camera as a slow technology, an instrument with which he became the first to capture and then develop and process Till's image, extends the brutality in a myriad of directions. Despite the comprehensive evidence, it took only sixty-seven minutes for the all-White jury to return a verdict of "not guilty" for Till's killers.

An image of Till in his casket was first published in a September 1955 feature in *Jet* magazine, written by Black reporter Simeon Booker. Founded in 1951, *Jet* was an African American print publication with a core Black readership. The magazine's feature on Till shared with the world his mutilated visage. The black-and-white image was taken by Black photographer David Jackson, responsible for this second image made of Till after those taken by the White C. A. Strickland at the funeral home.

Jackson took the photos of Till after his body was returned to Chicago. Jackson met Till's mother at the station and traveled with her to the funeral home there, standing with her as the casket was opened. In these images, Till is dressed in a suit.[8] The publication and viewership of this image is cited as a formative moment of national consciousness-raising, marking for many the beginning of the civil rights movement in the United States.[9] Booker, the reporter, told the *New York Times* in 2005, "I thought at first it was a horrible looking picture." The impact of its publication, however, was explosive: *Jet* was tasked, for the first time since its founding, with reprinting an issue due to popular demand.

The monstrosity of the image was a national turning point, albeit a complicated one. In the same article, Chris Metress, editor of the 2002 anthology *The Lynching of Emmett Till*, notes:

> You get testimony from [W]hite people coming of age at the time about how the case affected them, but you don't get them

testifying, like countless [B]lacks, that the *Jet* photo had this transformative effect on them, altering the way they felt about themselves and their vulnerabilities and the dangers they would be facing in the civil rights movement. Because [W]hite people didn't read *Jet*.[10]

The reason for this "transformative effect" can be found with Mamie Till-Mobley, the mother of Emmett Till, who, when she visited the funeral home to identify her son, discovered that he had been rendered unrecognizable. Despite her pain at the brutality of her son's disfigurement, she requested that the undertakers leave the casket open. Till-Mobley is quoted as saying to the funeral director, "Let the people see what I've seen," and "Let the people see what they did to my boy."[11]

The circulation of Till's image within a site intended to be engaged for and by Black readers established a radical enclosure of collective intimacy. *Jet*'s viewership in this moment shapes tenderly what writer and film theorist Manthia Diawara terms a "resisting spectator," an active, "for-us-by-us" sanction against a visual culture keen to identify and center a "[W]hite hero" in lieu of a Black martyr.[12] Instead of mobilizing Blackness without Black consent, or without recognition of Black life as deserving of belonging and agency ("No Humans Involved"), Till-Mobley's decision to hold the mirror up to the society that had done this to her son made it impossible for the viewer to turn away from its reality.

This collaboration between Till's mother and Jackson as photographer is sonic at a shattering decibel. Listening to images, as Tina M. Campt reminds us, underscores this excruciating mechanical reproduction: "That too is a form of labor." Conversely, through the looking glass, photographer Dave Mann's *Till Boy's Funeral, Burr Oaks Cemetary* [sic], taken at the funeral itself on September 6, 1955, depicts the reaction of the viewer to the horror of the body, without showing the body itself.[13] The viewer witnesses the absolute anguish of two Black

women, one with a gloved hand reaching skyward, as they seem to peer into the face of Till himself. Here we see the boy's mother and grandmother. A counter-reflection of Jackson's portrait, Mann's photo is chilling and world bending. Till-Mobley, frozen in the imaging of this shattering anguish and vulnerability, engages what social critic and educator bell hooks terms as an "oppositional [B]lack gaze," one that pronounces: "Not only will I stare. I want my look to change reality."[14]

In 2017, White American artist Dana Schutz presented a painting of Emmett Till at the Whitney Biennial in New York City. The piece, titled *Open Casket* (2016), showed Till in what reads formally as engaging the histories of abstract painting: lush swaths of color in the place of the nuanced grayscale of Jackson's original black-and-white photograph.

Perhaps this is why, then, Schutz's image presented such a seismic rupture within the social contract established between Till-Mobley, her son, and *Jet*'s audience: the artist made a decision that extended beyond the parameters asserted by Till's mother. Schutz kept the coffin open for "public viewing," but only during museum visiting hours, without considering first the volatile fault lines of consent that arc from that moment in the funeral home in 1955 to the present day. Till-Mobley and Till's open casket were never intended to be entangled in the cross hairs of "mixed company."

Still, too, allowing the art historical expression of abstraction to be the primary mode of presentation for this work amplifies a "blur[ring]" of the original image.[15] Schutz's visual strategy distorts its sonic nature, thereby transforming the ways in which we are able to listen actively. African American studies scholar Jared Sexton asks: "What is the nature of a human being whose human being is put into question radically and by definition, a human being whose being human raises the question of being human at all?"[16] In Jackson's original image, Till is shown as a monster, martian, and alien, the photograph stretching the

legibility of his form as *human*, transmogrifying his enfleshed body, mutilated beyond recognition, into a dystopic vehicle of supernatural horror, an invention of the White imagination. In a twist of extended violence, Schutz turns the body into static, a disruption of its intended sonic and visual messaging.

What was to be done? Writers Jo Livingstone and Lovia Gyarkye, in a 2017 article for the *New Republic*, described the call for the destruction of Schutz's painting as "a call for silence inside a church," asking, "How will you hear the dead boy's voice, if you keep speaking over him?"[17] Black studies professor Christina Sharpe responded to the controversy wherein Black visitors protested the work by standing in front of it, blocking it from view, noting:[18]

Wake work is the work that we Black people do in the face of our ongoing death, and the ways we insist life into the present. I think it's really powerful that those Black young people put their bodies in front of that painting. For me, that is a wake. Those young Black people are keeping watch with the dead, practicing a kind of care.[19]

It is, then, the tender Black readership and response to Schutz's artwork, and the desire that rises to protect Till's image as represented therein, that becomes the ultimate resistance against consumption, the production of spectatorship, and any assumption of its intended audience.

The anniversaries at the ten- and twenty-five-year marks of Till's murder "passed unobserved, even in the [B]lack press."[20] In 1985, on the occasion of the thirtieth anniversary, Rich Samuels, a Chicago reporter, produced a thirty-minute documentary on Till and the surrounding case, parts of which were subsequently broadcast on NBC's *Today* show.[21] These quieted milestones made 2020—a year marked by the beginning of a global pandemic, and uprisings around the world in the name

of Black Lives Matter—all the more significant in marking the sixty-fifth anniversary of Till's murder. Uncomfortably, that September 2, just four days after the official anniversary, Black American singer-songwriter Teyana Taylor released her music video "Still."

In the video, Taylor performs the song in a rotating reenactment of characters, dressing up as and re/performing figures such as Mamie Till-Mobley, Malcolm X, Black Panther Huey P. Newton in a wicker chair, Trayvon Martin in his now-iconic hoodie, Breonna Taylor in her medic uniform, and a handcuffed George Floyd in a black undershirt.[22] The video was met with glowing reviews of solidarity and has been played over a million times on Taylor's official YouTube channel.[23] Thus, in popular culture, Till has been transformed from martyr, to myth, to mythological meme.

Blackness is a deathly myth in the construction of American selfhood. Experimental composer, musician, and Afrofuturist Sun Ra, in his 1974 science fiction film *Space Is the Place*, observes:

> I'm not real, I'm just like you. You don't exist in this society. If you did, your people wouldn't be seeking equal rights. You're not real. If you were, you'd have some status among the nations of the world. So we're both myths. I do not come to you as the reality, I come to you as the myth, because that's what [B]lack people are—myths.

Ra's statement puts forward a painful proposition. The question of mythology, and the ways in which it embeds itself in a discourse of *wildness* (Blackness) set against *civility* (non-Blackness), is important to consider at the necropolitical crossroads of *Black social death* and *Black corporeal death*. To exist in a civil society and thereby be protected by the rights a civil society affords, one must be viewed as a human. When we engage Blackness as mythology, it becomes open-source

material, meaning that it can be hacked, circulated, gamified, memed, and reproduced.

It is this open-source model that drives what social scientist Kwame Holmes expands on as a form of "necrocapitalism"—an extension of political theorist Achille Mbembe's *necropolitics*— that makes "the value of Black death" a fungible commodity, worthy of exchange.[24] Holmes cites the rise in "home prices in the St. Paul suburb [of Falcon Heights] … at an impressive clip of 13%" in the wake of the murder of Philando Castile by officer Jeronimo Yanez, live-streamed by Castile's partner, Diamond Reynods, calling it "the area's most robust bull market since the sub-prime speculative bubble."[25]

Here, the end of Black life operates as a signifier to those speculating on the real estate market in the area, an indicator of a neighborhood that, in its practices of surveillance and polic-ing, prioritizes its protection against the presence of Blackness altogether. We see another reverberation of this kind play out in George Zimmerman's 2016 auction of the firearm that the Sanford, Florida, neighborhood watch coordinator used to kill Trayvon Martin, an unarmed Black teenager, four years prior. The gun, with a purchase value of $350, sold for $250,000 via the website UnitedGunGroup.com.[26] Zimmerman, in an attempt to promote the sale, noted on the site that "the Smithsonian Museum in D.C." had entertained the purchase as a possibility, failing to note which specific branch of the museum might have made an inquiry.[27] On May 12, 2016, the Smithsonian posted to Twitter (now "X"), "We have never expressed interest in collecting George Zimmerman's firearm, and have no plans to ever collect or display it in any museums."[28]

After the acquittal of Till's two killers, Roy Bryant and J. W. Milam, "the [B]lack sharecroppers that once kept Bryant's Grocery in business refused their patronage, and the store was put up for sale less than a month after the trial."[29] Across the decades that followed, the building changed hands, eventually

purchased in the 1980s by the family of Ray Tribble, who was a juror in the 1955 trial. The site—now owned by Tribble's children Annette Morgan, Harry Tribble, and Martin Tribble—received "funding for rehabilitation under the Mississippi Department of Archives and History Civil Rights Sites Grant given its cultural and historical significance," in order to make renovations to the gas station just sixty-seven feet away, now known as Ben Roy's Service Station.[30] "After Annette and Harry purchased Ben Roy's Service Station in 2003," one observer notes, "the family owned everything in Money except the Baptist church and the decommissioned post office."[31]

The death of Till is its own economy and tradable material, strategically applied to advance the accumulation of non-Black individual wealth, which no doubt complicates intergenerational class implications. Over time, the Tribbles have received offers from parties interested in restoring it as a landmark in honor of the civil rights movement; still, the family has held on to the site. In 2018, it was reported that the Tribbles offered to sell the store to a prospective buyer for $4 million.[32] As of 2023, the address is listed on the real estate website Zillow as being "off-market."[33]

Blackness as an economy here engages the complex paradox of the aura of Black objecthood. Poet and cultural theorist Fred Moten reminds us that "Black objects can and do resist," but this is often in opposition to the transformation of a living Blackness (a Black life) into an *inanimate Blackness* (property).[34] The "Black object" is often treated as a symbol or fetish, ritualized by a White imaginary. Thus, this property becomes a form of memetic reliquary and icon, reproduced digitally for collective consumption online. What the late author Vincent Woodard describes as a "cultivated taste" developed by Whiteness—for a "delectable" Blackness—forces in a necessary "resist[ance by Black persons against] cannibalization and [a] struggl[e] mightily against the institutionalized urge for [Black] self-consumption."[35]

44

This consumption is an extension of a necrocapitalist frame-work—the transformation of Blackness into various tokens that can be bought, sold, or otherwise exchanged as capital. It is rendered stable through its framing as a form of adulation, remembrance, or spiritualism—a "romantic love" of a catatonic (motionless, dead, or otherwise rendered inanimate) Blackness.[36] The anti-Black assumption that "eating the other" (as bell hooks would name it) could ever be interpreted as an imitative form of flattery, an act of care, love, or expression of admiration, justifies a gourmandization of Blackness entirely as a necessary cultural nourishment, one that the modern world could not function without.[37] Art critic and philosopher Boris Groys, in his essay "Religion in the Age of Digital Reproduction," observes:

> One might say that religious ritual is the prototype of the mechanical reproduction that dominated Western culture during the modern period, and which, to a certain degree, continues to dominate the contemporary world. What this suggests is that mechanical reproduction might, in its turn, be understood as a religious ritual.[38]

Groys establishes a relationship here between a Benjaminian "mechanical reproduction" as a prerequisite to modernity and contemporary world-making alike.[39] If we know this to be the case, then a bridge between ritualized reproduction in the form of the Black meme as a key component of a capitalist structure is a critical one to cross. The Black person, reduced to a Black body, reduced to a Black object, is distilled into its aura; and it is the aura of Blackness that lends material property its value.

"Eating the other" is what makes possible that which curator and art historian Cherise Smith describes as an "iden-tity masquerad[e]."[40] By making Blackness a mutable drag to be donned, staged, parodied, and passed along for replication and remix, Black objecthood as a material property becomes a way of exercising and performing non-Black privilege and

social, cultural mobility. Viewed through this lens, an entire history of minstrelsy then becomes a baffling grab at the aura of Blackness. The seizure of a fictive presence and projection of the objectified "Black thing," rather than the reality of Black personhood itself, catalyzes a form of free movement and economic renegotiation.

If *dead Blackness* is worth more than Blackness in its animated form, it is, then, entirely logical to double down on shaping infrastructure and systems that calculate toward the ending of Blackness as a stain to scrub out, leaving behind the trace and aura to be reperformed and replicated infinitely. These are the eternal copies of copies that create a house of mirrors, the outcome being that the original Blackness no longer knows which way to look to recognize itself. These violations, in constant copy, echo and replay, become a moral and natural rite of passage for Black people. Poet, essayist, and playwright Elizabeth Alexander speaks to this looping experience in her article "The Trayvon Generation":

> They watched these violations up close and on their cell phones, so many times over. They watched them in near-real time. They watched them crisscrossed and concentrated. They watched them on the school bus. They watched them under the covers at night. They watched them often outside of the presence of adults who loved them and were charged with keeping them safe in body and soul.[41]

The questions surfaced here are bound up within the modalities of a transmitted Blackness: virality, as a key agent of fungibility, is an appropriated technology.[42] The capture, captivity (to return to Harmony Holiday's words at the opening of this book)—and conversely, the emancipation—continues to confound, because it indicates that memetic transfer of Blackness cannot be coded via a Black/White binary, singular in dimension, but rather a multivalent political and social location.

Black feminist theorist Hortense Spillers speaks to the trouble of "captive" Blackness as "locat[ing] precisely a moment of converging political and social vectors that mark the flesh as a prime commodity of exchange."[43]

Thus, a dilemma, heartbreaking in its profundity: faced with Blackness—in life, in death, and in reanimation, via re/performance—as a viable commodity, the Black image, as well as the objects and locations that advance the social and physical death of Black people, are made fungible contingent on their perpetuation, the impact of their capital bolstered by the erotic of the violence they promise. The promise of harm gone viral is an economic strategy.

3

SELMA ON MY MIND: PROTEST, MEDIA, AND VIRAL WITNESS

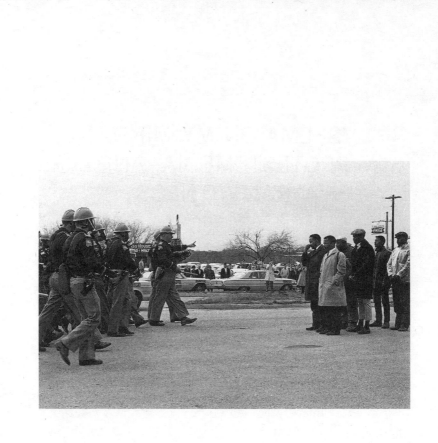

"So obvious but if those rioters had been Black / First of all they wouldn't have had time to scale those walls / looking like toy green soldiers."

—Pamela Sneed[1]

The bridge is an architectural icon of modern American industry, a symbol of progress as well as a pathway toward freedom. It has saturated our visual culture. A simple Google search for "protest bridge united states" surfaces thousands of images of people marching over US bridges across various moments of significance in American history. At this writing, the top two hits show the *Wikipedia* entries for "Edmund Pettus Bridge" and "Selma to Montgomery marches." This bridge—"built over the Alabama River, a key route for the state's plantation and cotton economy during slavery and Reconstruction" and named after a Confederate general and an Alabama leader of the Ku Klux Klan—creates a radical fault line for what, in March 1965, became the stage for three marches along a fifty-four-mile stretch of highway from Selma to Montgomery.[2]

A couple of weeks earlier, a few thousand miles away in Cambridge, England, the context of these marches had been a subject of debate within a very different forum. On February 18, in a televised debate held at the university, Black American author and activist James Baldwin dominated White conservative American commentator William F. Buckley. The two met to respond to the proposition "The American Dream is at the expense of the American Negro," where Baldwin argued in favor and Buckley in opposition.[3] Much to Buckley's umbrage,

Baldwin was received by the audience in a standing ovation and by audience ballot beat Buckley 544 to 164.[4]

In this debate, Baldwin opined on the afterlife of American slavery. He argued that though Black Americans had contributed physical and intellectual labor toward the shaping of an American capitalism deemed worthy of dreams, they remained systemically and strategically deprived of its benefits. "It comes as a great shock around the age of five, or six, or seven, to discover that the flag to which you have pledged allegiance, along with everybody else, has not pledged allegiance to you," observed Baldwin early in his remarks.

This, of course, was made clear in a matter of days in Selma. The first two of the three marches from Selma occurred on March 7 and 9, marking another major turning point for the civil rights movement, this time galvanized by the recent murder of twenty-six-year-old Black artisan, Baptist deacon, and civil rights activist Jimmie Lee Jackson at the hands of White Alabama state trooper J. Bonard Fowler. On the day he was killed, Jackson was participating in a rally with his mother, sister, and grandfather in support of another civil rights worker, James Orange. Orange, an assistant to Dr. Martin Luther King, had been jailed for enlisting young people in support of the registration of Black voters in Alabama. When conflict broke out in the crowd, Jackson and his family took refuge in a nearby café but were followed by state troopers, one of whom was later identified as Fowler.

Jackson later died from gunshot wounds, yet no one was held accountable. Fowler claimed Jackson was "trying to grab his gun."[5] Years later, in a 2005 interview with the *Anniston Alabama Star*, the officer maintained that though Jackson had no weapon with him, he had acted in self-defense. Nevertheless, two years later, Fowler, at the age of seventy-seven, was indicted on charges of first- and second-degree murder, pleading guilty to misdemeanor manslaughter.[6] While it was noted that the troopers had actively followed the fleeing Jackson and his family into

the café, Fowler explained: "He was trying to kill me ... That's why my conscience is clear."[7] Fowler served five months of a six-month sentence before being released. In 2010, Jackson's name "appeared on the Department of Justice's list of cases it was reviewing under the Emmett Till Act."[8] As Fowler had already been found guilty of state charges, the Department of Justice determined that it could not pursue federal prosecution. The case was closed in 2011.

On March 7, 1965, the American dream clashed with a waking nightmare when armed White state troopers and sheriff's deputies met with the first Selma-to-Montgomery march, a 600-person civil rights demonstration led by young activist (and, later, revered Democratic statesman) John Lewis with a violent series of attacks that nearly cost the twenty-five-year-old Lewis his life.[9] He was hospitalized along with seventeen others.[10] This march—which became known as "Bloody Sunday"—was planned in response to Jackson's murder. It was also in conjunction with the ongoing demonstrations against the tactics of fear and intimidation deployed by White Americans to keep Black Americans from registering to vote in the South.

In addition to the march itself, we must note how it was recorded. Had it not been on national TV, the nation never would have known so fully and unequivocally what had occurred in Selma that day in 1965. Before 1960 and the Kennedy presidency, as one report notes, "television was far behind print journalism in terms of sources audiences relied upon for news."[11] By the 1960s, nearly 90 percent of households had TV sets, yet at the time there were only three channels: CBS, NBC, and ABC. Early television broadcasting had a stronghold on significant power: it became a critical instrument and unifying force for viewers because if one had a TV at home, the programming on offer was identical to that being screened across the hall, street, and country.

This was entirely unlike the circulation of print journalism, which presented many more options to choose from and where

readership was often informed by geographic region and political allegiance. With no "single lens" unifying it, print media presented multiple perspectives—and disseminated misinformation based on these perspectives—meaning that audiences were often split in attention, participation, and modes of readership. However, when something tectonic happened on television, everyone experienced it at the same time.

The inclination in print toward politicized misinformation is exemplified by local coverage of the Alabama marches. On March 31, 1965, the *Montgomery Advertiser* ran a headline reading "Drunkenness, Sex Orgies Blemished March—Dickinson," quoting Alabama Republican congressman William L. Dickinson.[12] This clipping, which reported Dickinson's statements in the congressional record of the apparent goings-on surrounding the Selma–Montgomery rallies, reads something like pulp fiction.[13] Dickinson claimed lavishly that "drunkenness and sex orgies" in the encampments of demonstrators at Selma along with "the Communist Party and the Communist apparatus [are] the under-girding structure for all of the racial troubles in Alabama for the past three months."[14] Conversely, *Time*, as a print magazine in national circulation with a more progressive editorial line, reported on Dickinson's rash and racist allegations in a sardonic tone, criticizing the congressman for his role in perpetuating fake news: "[Dickinson] likes to make a splash. Last week he splashed mud all over the House floor. But only Dickinson got dirty."[15]

Richard Valeriani, a former NBC News correspondent who reported from on the ground in Selma, shared in the championing of live media: "The TV coverage was much more important than the *New York Times* coverage."[16] Even so, "in 1965 instant live feeds from remote news sites were not possible. There were no satellite trucks. Newsfilm was film[ed] and had to be developed and flown to New York before it could be broadcast to the nation."[17] This meant that while the circulation of the state violence enacted onto Black organizers

screened freely in living rooms across America, the screening itself was a representation of events that had already passed. The importance of this disconnect should not be overlooked: the nation responded not in "real time" but in the aftermath of a national trauma, an echo of an aftershock. It lent a theatricality to watching the news and is what American national evening news anchor Dan Rather observed in an interview as "a kind of televised morality play" that "appealed to people of faith across the country ... incit[ing] demonstrations in over 80 cities across America."[18]

Let us delve further into the ways in which this coverage was experienced and the cinematic nature of the reaction it evoked. That Sunday, March 7, ABC's news division interrupted the network's prime-time programming to show the footage of the conflict at Pettus Bridge. As today, Sunday night was a popular time to watch television; that evening in 1965, ABC was screening Stanley Kramer's *Judgment at Nuremberg*, a film with a star-studded cast including Judy Garland and Marlene Dietrich. Kramer's film confronted the realities of the Holocaust and, as NBC News later reported on the occasion of the fiftieth anniversary of "Bloody Sunday," challenged "the moral culpability of Germans in the genocide of Jews."[19] Forty-eight million people were tuned in watching the film when the coverage switched over to the march in Selma. NBC observes, "The juxtaposing of a narrative about Nazi brutality towards victimized Jews with footage of Southern segregationist brutality against victimized [B]lacks was incredibly powerful."[20]

Such shocking scenes provoked unprecedented compassion from the nation looking on, seeing Black people in their humanity and vulnerable corporeality. The broadcast made physical the impact of state violence in-motion; no longer was it a static material solely in print circulation. Rather, families at home could not turn away as they watched bodies in real pain—pain now given a voice and face, set on playback into eternity. This historical documentation violated the principles of a White

America in its dreamstate: the organization of domestic spaces that did not host Black people.

Two days later, journalist Charles Morgan Jr., who was at the time the southern director of the American Civil Liberties Union, met with clergy who had traveled from out of town to Selma. He shared stories of what motivated people to join the second demonstration: "I was watching 'Judgment at Nuremberg,' and I just couldn't stay away. I just had to come."[21] After this national broadcast, what began as a march of 600 on March 7 transformed into a rally of 2,000 in two days' time.[22]

Yet this was only a precursor to the protest attended by over 25,000 people who made their way from Montgomery to Selma later that month, between March 21 and 25—a dissent that overcame barriers of race, class, and gender. The demonstrators represented an integrated, viral viewership, perhaps even an example of a pre-internet, media-generated "flash mob." This cultural glitch—the splicing of media, and accidental political intervention—advanced and cultivated empathy across the nation in a way that had not been seen before.

These events were significant and transformative, marking a historical turning point as they laid the groundwork for President Lyndon B. Johnson's signing into law the Voting Rights Act in August of the same year.[23] The 1965 legislation was the most comprehensive voter rights protection ever witnessed in the nation's history, galvanizing voter registration across the country, but most urgently in the South. The signing of the law brought a quarter of a million Black voters to register.[24] At the conclusion of the 1960s, the eligible Southern Black vote had nearly doubled, rising to around 65 percent from a previous low of 35 percent. Not only was the expansion of this law a major win for Black Americans; it also became critical to future protections of non-English-speaking citizens, which would make it illegal to discriminate against other populations, such as Latinx people, who were being purged from voter registration in states like Texas.[25] Black Americans, resolved in their

struggle, held this necessary space and, in doing so, shaped this future for all people.

Nearly half a century later, Black American film director Ava DuVernay's 2014 drama *Selma* grossed almost $67 million at the box office, 78 percent of which was generated in the United States. In DuVernay's depiction of the confrontation at Selma, the viewer is placed at the epicenter of all the violence; yet, as reported by NBC, "once tear gas explodes, viewers can't see very much. The footage becomes like a horror film: we hear coughing, screaming, beating, but the monstrousness is obscured."[26] This presents an entirely different perspective than the one viewers encountered that Sunday night of March 7, 1965, where news coverage showed the full arc of what unfolded and amplified the theatrical tension drawn across opposing sides. It is thus the documentation of the march, mediated by the networks that shape our cultural consciousness of protest, that is played back to us on loop time and again, across a variety of platforms.

The imagery produced via film and still photography in March of 1965 also establishes a blueprint for documentation and its memetic transfer as it manifests today. To take one example: when White photographer Jonathan Bachman imaged the Black Brooklyn-born nurse and mother Ieshia Evans protesting in Baton Rouge the deaths of Alton Sterling and Philando Castile, its publication by Reuters in July 2016 made the photo a viral sensation. The photo of twenty-eight-year-old Evans, now titled *Taking a Stand in Baton Rouge*, in its composition —Evans standing peacefully to the right as armed troopers approach her from the left—closely echoes the iconic image *Two Minute Warning*, taken of civil rights activists John Lewis and Hosea Williams by White photographer James "Spider" Martin. In Martin's black-and-white image, we see Lewis in a white trench coat with Williams at his side, peacefully standing with a group after crossing the Pettus Bridge into Dallas

County. State troopers to the left of the frame approach with arms outstretched in the foreground as onlookers bear witness in the background, from between parked cars.

Evans, reflecting on her act of state refusal, wrote on Facebook: "I am a vessel! Glory to the most high!"[27] The comparison Evans makes between her physical form and the material of the container, a "vessel," underscores the dilemma of Blackness as a frame. Blackness is both a vessel made to carry and a vessel to be projected onto. In an interview that same year, Evans reflected on the complexity of that carrying, and its relationship to the expectations held by the public of those catapulted to fame through viral celebrity: "When [people] get a glimpse of who I actually am, they don't like it."[28]

Here, as well, we begin to see a rise in a new type of circulation of the Black meme as the shared digital imagery, and GIFs as an extension to this, form new publics and possibilities of witness, participation, spectacle, and home entertainment, all at once. In the summer of 2020, as bridges across the nation and around the world were shut down by people marching for Black life, the coverage—now more often streaming live, rather than after the fact—harks right back to 1965. However, this time the images are shown and viewed from a myriad of angles, inherently complicating our attempts toward shaping a full image and consensus on what is "real" right now. The multiplex shifts in power that come when the camera is in the hands of a distributed many are part of the possibility presented here. Coverage is no longer dictated by those carrying the assumed expertise of the "established media" but instead distributed by the everyday witness carrying a smartphone. The blend and blur of the public's role in news reportage pushes us to further consider the ways in which the materials one produces through the act of viral witness can trigger a real-time response.

John Lewis's words guide us here as we consider the impact of this televised memetic transmission: "Without television news coverage, the civil rights movement would have been like

a bird without wings, or a choir without a song."[29] Still, with
Black people as "raw material" driving the transformation
of American storytelling,[30] our collective memorialization of
the turning point of 1965 necessarily comes with qualifica-
tions: though movements for Black civil rights achieved lasting
change, we must ask, on whose terms did such rights become
thinkable, and via what memetic channels were they conveyed?
For alongside the amplified possibilities of political empower-
ment comes the voyeurism and extractive violence of mass
media as the broadcast of Blackness plunges further into—and
defines—popular culture.

4

SPORTING THE BLACK COMPLAINT: JOHN CARLOS AND TOMMIE SMITH, SILENT BLACKNESS, AND MEMETIC NATIONHOOD

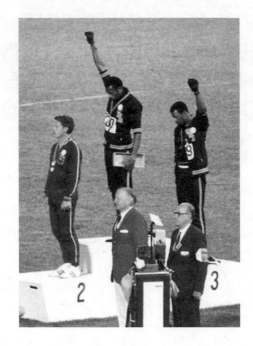

"I'd like to tell [W]hite people in America and all over the world that if they don't care for the things [B]lack people do, then they shouldn't sit in the stands and watch them perform."

—John Carlos[1]

An article in *Time* magazine of October 25, 1968, began with pronounced disdain:

"Faster, Higher, Stronger" is the motto of the Olympic Games. "Angrier, nastier, uglier" better describes the scene in Mexico City last week. There, in the same stadium from which 6,200 pigeons swooped skyward to signify the opening of the "Peace Olympics," Sprinters Tommie Smith and John Carlos, two disaffected [B]lack athletes from the U.S. put on a public display of petulance that sparked one of the most unpleasant controversies in Olympic history and turned the high drama of the games into theater of the absurd.[2]

The subject of this article was made plain via the printing of an image of two Black athletes, Tommie Smith and John Carlos, taken just a week before, on October 16. Each, wearing a single black glove, raises their fist. In this photo, Smith and Carlos are pictured without shoes and with knee-high black socks, sharing the award pedestal with White Australian silver medalist Peter Norman.[3] The *Time* piece, saturated in dog-whistle code, responds to the collective protest of Smith, gold medalist, aged twenty-four, and Carlos, bronze medalist, aged twenty-three, at the athletic competition watched by the whole world. The *New York Times* failed to do much better, printing, misleadingly,

an article with the baiting headline "2 Black Power Advocates Ousted from Olympics."[4] As "The Star-Spangled Banner" played on, the two Black American athletes faced the flag, raised their fists into the air, and bowed their heads in a silent protest. The gloves raised by Smith and Carlos—left and right of the same pair—have since become iconic: a mutual salute in support of the struggle for human rights.

In the aftermath of their public refusal, while headlines critizing their act were prevalent, the image of Smith and Carlos itself did not appear as front-page news; even *Sports Illustrated* did not feature the photo in the issues that immediately followed the event. It was relegated to page 78 of *Newsweek* coverage, making somewhat of a cultural footnote in its anecdotal narration. The lion's share of print and televised media focused instead on Smith's record-breaking 200-meter sprint. This redactive relensing was a feat unto itself that reified an idea of Black excellence and success starkly in the face of the ongoing systemic abuse of Black people and their civil rights in the neighboring United States.

The protest took center stage, however, when it was mentioned on live TV by emerging anchor Frank Reynolds on the *ABC Evening News* on October 17, 1968, the day after the race. Reynolds commented casually:

> The United States leads the Olympics in medal awards and is just about supreme in the sprint races thanks to men like Tommie Smith and John Carlos ... Yesterday, they came in first and third in the 200-meter dash and then stood on the victory platform with bowed heads, wearing black socks and gloves in a racial protest.

In the broadcast, footage alternated between Carlos and Smith alongside Norman, and imagery of the American flag being hoisted at the Olympics. Reynolds continued in his reporting, contextualizing for ABC's audience:

Before the Olympics there was a furor in this country over a threatened boycott by Negro athletes, then most of them decided that participation in this Olympics would further the cause of civil rights in this country and abroad. The Negro athletes wear buttons reading "Olympic Project for Human Rights." There were some boos in the stadium last night.[5]

On national television, a young Smith explained to White, middle-aged ABC Sports editor Howard Cosell:

The right glove that I wore on my right hand signified the power in [B]lack America. The left glove my teammate John Carlos wore on his left hand made an arc, my right hand to his left hand, also signifying [B]lack unity. The scarf that was worn around my neck signified [B]lackness. John Carlos and me wore socks, black socks, without shoes, to also signify our poverty.[6]

Smith's engagement of poverty as a critical issue harks back to the assassination of Dr. Martin Luther King Jr., whose life had been taken six months prior, as the civil rights leader had been organizing support for his Poor People's Campaign. The campaign was significant—and threatening to many—as it geared toward a universalized effort that was pointedly intersectional and multiracial, advocating for economic justice and unity that transcended the binaries of race, class, and gender.

Following on the heels of President Lyndon B. Johnson's 1964 declaration of "unconditional war on poverty in America," and the social welfare legislation it sought to enact, Dr. King's vision for the Poor People's Campaign reinvigorated Johnson's initial call to action that had fallen by the wayside in the last four years. Thus, for Carlos and Smith to stand in support of "Black unity," while also promoting resistance against America's ongoing economic disenfranchisement, defied assumptions surrounding athletic celebrity as a vehicle for the possibility of

being "beyond" one's race or class. In the wake of Dr. King's death, American civil rights activist and Baptist minister Ralph Abernathy and the Southern Christian Leadership Conference took up the task of carrying forward the Poor People's March on Washington, delivering thousands to the nation's capital between the months of May and June 1968.

It is with some irony that years later—in the midst of a global pandemic and a resurgence of the debate surrounding American sports entertainment as a platform for athletes to articulate solidarity with Black Lives Matter and other movements —the *New York Times* observed in 2021: "The greatest misinterpretation of Smith and Carlos's protest was that it was somehow about Black separatism. Instead ... it was about human rights through the particulars of Black people's struggle."[7] In their protest, Smith and Carlos called attention to the need to reconcile the failures of care for Black and poor people as an action that, in its very implications, might benefit all people by improving the economic conditions of Americans across a myriad of backgrounds and localities.

This was finely stitched in the athlete's choice of dress. The socks worn were an active condemnation of the economic conditions of Black people in the United States, and a rejection of global poverty and hunger across nations. Refusing the best practices of the Olympics uniform, both Smith and Carlos unzipped their tracksuit tops, a "tribute to the struggle of the blue-collar worker everywhere."[8] Draped around Carlos's neck, right alongside the bronze medal, laid a string of beads.[9] In the wake of their protests, Carlos spoke to the media on the significance of the necklace, noting: "[The beads] were for those individuals that were lynched, or killed that no one said a prayer for, that were hung and tarred. It was for those thrown off the side of the boats in the Middle Passage."[10] Years later, in his 2011 book *The John Carlos Story: The Sports Moment That Changed the World*, coauthored with American sportswriter Dave Zirin, Carlos remembered: "I fingered my beads

and thought about the pictures I'd seen of the 'strange fruit' swinging from the poplar trees of the South."[11]

Carlos engages in remembrance and prayer, ritualized in his touching of his beaded necklace. His reference to "strange fruit" calls to mind the iconic picture taken by Lawrence Henry Beitler in August of 1930 in Marion, Indiana: the viral photograph discussed in chapter 1, bearing witness to the lynching of Black teenagers Thomas Shipp and Abram Smith. Thus Carlos, in the action of donning the string of beads, beckons forth a direct connection to a sequence of imagery, echoes of visual culture in memetic replication arcing devastatingly over time. In this gentle gesture, Carlos resurrects Shipp and Smith; Carlos's beads are all at once a rope, a string, and an umbilical cord to the birth of Beitler's original viral image.

Carlos, in considering the death threats that came to him and Smith before, during, and after their shared protest, draws out the perils of "living while Black" as a condemned state in a racist nation: "As a teenager, a young [B]lack man, I was born dead so for someone to put a threat on my life, my philosophy was 'I'm going to die anyway.'"[12] In this turn, Carlos establishes the document of his and Smith's right to life as being inextricably intertwined and bound up in the document of Shipp and Smith's brutal murder—a state of "living dead" amplified and made manifest by the travel of these images at a speed and scale across visual culture that renders it impossible to comprehend beforehand the full arc of their impact.

The image of Carlos and Smith—with the memory of Shipp and Smith encrypted tenderly within its data—has been heralded as "one of the most influential protest images of all time."[13] The image was taken by *Life* magazine photographer John Dominis; in a 2013 obituary the *New York Times* describes Dominis as being "caught off guard himself while taking his most famous picture ... of two American medal winners raising black-gloved fists at the 1968 Olympics."[14] Dominis "freezing" that moment suspends Carlos and Smith inside of the image

indefinitely for generations to come.[15] In his book, Carlos recalls raising his fist: "The stadium became eerily quiet ... There's something awful about hearing fifty thousand people go silent, like being in the eye of a hurricane."[16] Carlos's recollection blurs the experience in real time as Dominis's image is being produced, with the timeless nature of being frozen in the political action of performing refusal, a spectacle in the public realm set into motion via its vast circulation within the media.

Thus, the image becomes a portrait of a turning point in history. It is also the blueprint and harbinger to American footballer Colin Kaepernick's sitting on the bench during the national anthem nearly fifty years later in August 2016. Kaepernick's refusal was first imaged by beat writer Jennifer Lee Chan without much recognition in the mainstream media.[17] Kaepernick's practice of kneeling on field during the anthem, an act which began a month later and, in its virality, became a resounding symbol: a Black athlete's protest, rejecting police brutality in the embrace and uplifting of Black life.[18] A myriad of other public figures in sports followed in suit and solidarity.

We see a lineage as well between the image and artful action of Smith and Carlos in the defiance of twenty-five-year-old American shot put silver medalist and Black queer woman Raven Saunders, who raised her hands over her head in an "X" in the Summer 2021 Olympics, an action that Saunders described in an interview as being symbolic of "the intersection of where all people who are oppressed meet."[19] Saunders makes current the call for solidarity across marginalized people around the globe, a call to action that engages and critiques the constructs of race, class, and gender, shattering binaries.

That same year, *New York Times* reporter Adam Bradley observed the persistent memetic transmission of the image of Smith and Carlos into contemporary visual culture, describing the wares of Harlem street vendors: "One memorable shirt shows three athletes on the medal stand: a [W]hite man looking straight ahead and two Black men with heads bowed and arms

outstretched, their black-gloved fists raised high in the air."[20] Bradley muses in his piece, "What happens when a person becomes a symbol?" and then, "What happens when a symbol becomes a person again?" noting, "Smith and Carlos's protest did not invent the raised fist, but it may well have apotheosized it." Bradley's use of "apotheosized" underscores the intensity of idolization as manifest in Smith and Carlos's historic action, their hands a relic to the public imagination.

In a critical moment where media coverage was in acceleration transitioning from radio to television, American networks ABC, CBS, and NBC paved the way; by 1960 the United States was at the forefront, leading in its use of at-home television sets. Intersecting increasingly with the coverage of political ferment across the nation, televised sports coverage galvanized viewership.

The 1968 Olympics were the first time that the games had been shown in color, and with slow-motion replay. ABC paid $7 million for the rights to air the Winter and Summer Olympics of that year, victorious in a bidding war against NBC. Robert Trachinger, an ABC Sports executive, was credited with the "first hand-held camera" and "the first successful … slow-motion video tape" technique along with Roone Arledge, then president of the network.[21] These technologies and techniques made it possible for there to be a more intimate engagement of sports viewership, the coverage of games such as the Olympics becoming as much about the wins and losses as about the real-time documentation of the trials and tribulations of the athletes.

Smith and Carlos stood before those same cameras. Smith, in talking about the life of the action and the afterlife of the image, makes known the tension between *visibility* and *representation*, underscoring the haptic nature of listening to images, photographs with sonic utterance: "[It was] a cry for freedom and for human rights. We had to be seen because we couldn't be heard."[22] In his 1997 autobiography *Silent Gesture*,

Smith reflects on the somatic strategy of this moment: "That was my victory stand ... training my body and my mind for the ultimate achievement ... my silent gesture was designed to speak volumes."[23] Smith's insistence on hypervisibility as a form of resistance against a failure of real representation brings momentum to a manifesto for Black viral culture that continues to spool outward from here.

VIRAL ZOMBIISM: MICHAEL JACKSON AND "THRILLER"

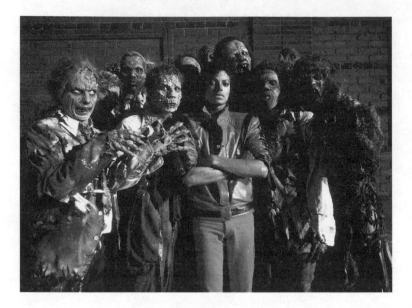

"Let's make a movie called Dinosaurs in the Hood. / Jurassic Park meets Friday meets The Pursuit of Happyness. / There should be a scene where a little [B]lack boy is playing / with a toy dinosaur on the bus, then looks out the window / & sees the T. Rex, because there has to be a T. Rex."

—Danez Smith, "Dinosaurs in the Hood"

The debut of Michael Jackson's "Thriller" music video in 1983 is an important turning point in the history of the Black meme. "Thriller" became a media sensation, setting the stage for and putting clearer visual language to what we might now know as the "viral video." Released into the world to international acclaim and excitement, the video received ample airtime on MTV at a time when few Black artists were featured on the channel.

A deeply complicated and controversial figure, Michael Jackson was an American superstar who rose to amplified fame following his child celebrity, emerging as a breakout talent within family pop band the Jackson 5. Over four decades, the "king of pop" charted a career that transformed global visual culture through his innovations and contributions to music, dance, and fashion.

While the *Thriller* album had been released the year before, the music video for the title track gave new visibility to Jackson's number, with an extended length of thirteen minutes and forty-two seconds that brought the dynamic narrative, choreography, and directorial vision of feature films exclusively into the structural composition of a pop song. The music video was so impactful it doubled the sales of the album itself,

making it the best-selling LP in history; with a million copies of the "Thriller" video sold on VHS, it was also at the time the best-selling videotape.

While in 1950 only 9 percent of American homes had a television, by 1978 that figure had jumped to 98 percent.[1] Just two years later, in 1980, the Canadian company Viewstar launched the new and improved remote control—the first to make use of infrared technology.[2] With television now a dominant site of engagement for at-home media across the lion's share of American households, this paved the way for the entrance of the VCR—and the VHS tape—as a symbol of class ascendency and signifier of expendable income. While in 1980 fewer than 1 percent of American homes had a VCR, by 1987 this had risen impressively, to 50 percent.[3] Notably, in 1975 it cost approximately $2,200 to purchase the prototypical Betamax VCR; by the time 1987 rolled around, however, the VCR had become much more affordable for middle-class families, hovering around $250, with blank tapes available for five bucks or less—a drop from a former price tag of twenty dollars per cassette.[4]

While the disparity in income between Black and White families slimmed in the 1980s, in 1989 the median income for a Black household was $19,758, while for a White household it was $31,435. This meant that for every dollar earned by a White household, a Black household earned 63 cents.[5] Still, across the 1980s it becomes significant to note that as the cost of the television set, VCR, and VHS tapes went down, the class and access divides established early on regarding these technologies began to be bridged, creating new intersectional models of participation in visual and pop culture but also new models of transmission, ownership, property, and exchange.

Here, it is useful to consider what civil liberties scholar Cheryl I. Harris, in her 1993 essay "Whiteness as Property," denotes as "modern views of property defining social relations."[6] At this moment, the shift in access points for viewers was critical. The

falling price of at-home technology brought with it an increase of domestic consumption of visual broadcast media. As a consequence, viewership in one's home offered new and intimate ways to understand how visual culture could be experienced, disseminated, and economized. Illuminating this point, Harris argues that assumptions of *property* are codependent on both *expectation* and *transferability*—the assumption that one *can* own something and transfer it to another individual—leading to an expanded imagination of fungible ownership and exchange altogether.[7] She writes:

> Classical theories of property identified alienability as a requisite aspect of property … thus, that which is inalienable cannot be property … if inalienability inheres in the concept of property, then [W]hiteness, incapable of being transferred or alienated either inside or outside the market … fail[s] to meet a criterion of property.[8]

What happens, then, when one is offered the possibility of purchasing, owning, replicating, and transferring Black material, such as Jackson's *Thriller*? What expectations arise when we consider the power of the technology and the transferable portability of the content? The VHS—either legal or bootlegged—creates new relations of alienability: it can be endlessly exchanged as property. Jackson is made to perform his zombie stomp on a loop, with no say about where, when, and how he is consumed.

Jackson's "Thriller" changed completely how music videos were perceived, transforming them from a sort of unintellectual visual candy into something that could be taken seriously as a cinematic art form. It was directed by John Landes, already famous for classic films such as *The Blues Brothers* and *An American Werewolf in London*; that year, he was riding high with the successes of *Trading Places*. "Thriller" had a script and a storyline that played with iconic American teen movie tropes,

the two lead characters played by Jackson and Black actress and model Ola Ray—an echo in sartorial aesthetic and style of the 1978 film *Grease*. The video, which cost a staggering $900,000 (equivalent to about $2.7 million today), was launched with a Hollywood-style cinema opening at the Crest Theatre in Los Angeles, on November 14, with celebrities in attendance.

Despite this cinematic presentation, the video was intended for domestic consumption. It brought into homes a genre of Black movement never seen before: bodies possessed by Blackness that, choreographed by the renowned Michael Peters, twitched and glitched and writhed, exemplifying what scholar and critic Margo Jefferson observes as "avatar[s] of a transracial, transgender, and trans-species world."[9] Breaking down racial and cultural barriers as an international sensation that moved across the globe, "Thriller" established that Black viral media could be self-determined and directed, extended in duration, narrative in form, and transcend the limitation of language, space, or time.

Because transmission and the inherent power dynamics bound up within that process of making material move via memetic means, it is important to underscore that Epic Records, who represented Jackson at the time, chose to *give the video away for free*. At the time, the label thought that the album had peaked and that the video would not change its fortunes much. Seeing the video as a marketing opportunity for the album, Epic Records used it to leverage the album's content, sharing it globally to those they hoped might broadcast it. However, following the video release, Epic shipped a million copies of the album weekly. As 1984 reached its close, the LP had seen 33 million copies in US sales. From that point, *Thriller* has touted itself as being the number one album of all time, with more than 110 million sold worldwide since its debut. [10]

However, the sheer acclaim and virality of Jackson's "Thriller" on their own do little to convey what this video really meant, and what it *did*. Though of course we cannot assume nor should

we overlay Jackson's creative and commercial intentions in the production of this video, it seems key to look backward at 1983 and read "Thriller" as a cultural, political, and social text in and of itself.[11] "Thriller" was not released in a vacuum. In October 1982, President Ronald Reagan declared his "war on drugs," reanimating the words of Richard Nixon, who in 1972 had called for a "national emergency," stating that drugs were "public enemy number one"—words that in fact echoed those of his predecessor, Lyndon B. Johnson, who announced a "war on poverty" during his 1964 State of the Union address.[12]

The war on drugs was, at best, a dog whistle: the policies that arose during this period were violently punitive, giving cause for increased surveillance and profiling of Black and Brown people across the United States. In addition, for those caught and punished, extreme sentencing disparities set the stage for a rapid rise in incarceration within a burgeoning for-profit prison industry. The statistics are staggering: in the 1980s, while the number of arrests for all crimes had risen by 28 percent, the number of arrests for drug offenses rose 126 percent.[13] Refracting the emblematic undead figures of Jackson's video, journalist Michael A. Gonzales reflects on this period of time in a 2014 essay for *Ebony* magazine: the era "turned ... thousands into zombie[s]."[14]

Years later, in 2007, the "Thriller" dance itself became a meme when inmates in Cebu Provincial Detention and Rehabilitation Center—a maximum security prison in the Philippines—reenacted it en masse, becoming a viral sensation on YouTube.[15] While in some moments precise in citation, in others the restaging of Peters's choreography takes on its own interpretation. While in Jackson's original the female character, played by Ray, is never pictured being actively harmed by the zombie forces that shut around her, in the Cebu version we see inmates in their bright orange carceral uniforms feign an attack on a gay-identified inmate in a white tank top and jeans, performing Ray's character. Arcing the final several minutes of the video,

before the camera cuts to a pixelated screen dubbed with the haunting laugher of "Thriller," the literal dragging of a queered Ray—a theatrically mimed hate crime—is upsetting to watch.

The documentation of this collective action is both entertainment and a form of surveillance. The prisoners dance, but they also, to call on the words of curator and professor Dr. Nicole Fleetwood, "mark time." The unsettling feeling from watching the spectacle is that the viewer is complicit in this surveillance as recreation and entertainment. Viewed from an aerial position, we are sited at the vantage point of a watchtower prison guard, triggering a tension in what has been narrated as a "feel good" emancipatory moment to be shared and celebrated. Furthermore, the act of spectating becomes an extractive force, as what goes on behind prison walls should be a property to be turned into currency and exchanged as a document of the panopticon as a recreational site.

Alongside Jackson's "Thriller," another sense of viral zombie-ism comes into play. In 1982, just a year before the release of "Thriller," the Centers for Disease Control first used the term "AIDS" to describe a deadly new disease that was already reaching epidemic proportions.[16] At this moment, the world was only beginning to understand what AIDS was, and how the virus that causes it was transmitted. Exploited in the media via a constant engine of fearmongering and misinformation, this period triggered within cultural consciousness patholo-gized fantasies and fears of an apocalyptic futurity—one where the world falls into the grip of a global contagion driven by queer people, poor people, and people of color.

In the 1980s, neuropathologist W. R. Greenfield wrote an academic paper sensationally—exploitatively—titled, "Night of the Living Dead II," inquiring in its abstract, "Do necromantic zombiists transmit HTLV-III/LAV during voodooistic rituals?"[17] The resonance between Greenfield's racist and xenophobic fantasies enacted by his paper and the veiled critique of White

supremacy lodged by Jackson's video is no accident. American studies scholar Craig M. Loftin, on his blog on 1980s MTV culture, reflects on Jackson's "Thriller," noting,

> Being gay was scary, so scary you'd have to make a really scary video to express the fear of it properly ... fear of homosexuality informs the video's storyline and visual style ... The scene's dialog closely resembles a coming out declaration, pointing the audience down the dark scary forest path marked "queer."[18]

The scenes that show a transformed Jackson—now taking the shape of a terrifying werewolf in an American high school letter jacket—echo D. W. Griffith's *Birth of a Nation* and its chase sequence depicting a White woman running through a wooded area, away from a Black(ened) man.[19] This sequence is famously captioned "Stay away, or I'll jump!" suggesting that the White woman would rather die than be touched by Blackness. She eventually leaps to her death. In "Thriller" the tropes of terror are perpetuated through shape-shifting and zombification, the werewolf and the zombie mutually synthesizing the fears of race, class, and sexuality as deviant sites of alien evil, made worse by their potential to remain closeted, undetected, or unknown.

Thus, the language of race, sexuality, and class in the moment where Jackson's "Thriller" first stepped onto a global stage was all bound up within the language of zombiism—a myth that first surfaced in Haiti in the seventeenth and eighteenth centuries. At the time, Haiti was known as Saint-Domingue and was under the ruling hand of France, deeply implicated in the transport of African slaves to labor on sugar plantations.[20] Within the industrial complex of slavery, the Haitian zombie took two forms. In one version, the individual is "broken ... [and] made docile and servile," stripped of agency or autonomy to become "a machine of production ... [wherein] the loss of ... will" transforms the individual into a zombified figure—one

with a body, but without a soul. A second, alternate version of the zombie is more empowered, manufactured as the "revolutionary slave" who, in mutiny, "defeat[s] their masters" and so, unbroken, keeps their soul intact but perhaps loses their body along the way.[21]

Zombies, in a constant state of transmission, transformation, transmutation, and becoming, are the embodiment of the Black meme. To have a zombie music video like "Thriller"—where undead Black(ened) bodies are reanimated, empowered, collectivized—enter into the bloodstream of popular culture in 1983 is therefore nothing short of explosive. Zombies represented America's greatest fears, and here Jackson is embodying the trope in a way that had never been seen before. The video itself is a contagion that, in its transmission, transformed the memetic visibility of Black movement.

6

PARIS IS BURNING: VIRAL BALLROOMS AND MEMETIC ROYALTIES

"This is a recording. Trill mark the terror of being valued …
My favorite things fight concertization."

—Fred Moten[1]

In 1991, the award-winning documentary *Paris Is Burning* was
released for the first time in the United States to much critical
acclaim. The film chronicled the competitions and commu-
nity of "ball culture" in New York City in the 1980s. *Ball*
(or *ballroom*) culture is a social art form that originated in
Harlem in the late twentieth century. Described once by poet
and saint of the Harlem Renaissance Langston Hughes as the
"strangest and gaudiest of all Harlem spectacles," the ballroom
lent agency, allowing for a reimagination and reconstitution of
presence for those who participated in its community, many of
whom were traditionally constrained by the binaries of race,
class, and gender.[2]

In *Paris Is Burning*, named "houses," such as Xtravaganza
and LaBeija—queered nonbiological family formations unified
in their efforts to collectively care for and grow with one
another, both on and off the dance floor—compete with one
another for the recognition of "realness." Judith Butler, in her
1993 essay "Gender Is Burning," explains:

> "Realness" is not exactly a category in which one competes; it
> is a standard that is used to judge any given performance within
> the established categories. And yet what determines the effect
> of realness is the ability to compel belief, to produce the natu-
> ralized effect. This effect is itself the result of an embodiment
> of norms, a reiteration of norms, an impersonation of a racial

and class norm, a norm which is at once a figure, a figure of a body, which is no particular body, but a morphological ideal that remains the standard which regulates the performance, but which no performance fully approximates.[3]

Assured authenticity is central to the success of the performance on the ballroom floor. One's "realness" serves as a protective membrane against the exposure of being "read"—*reading* meaning to be chastised, mocked, ridiculed. The exercise of performing against any possibility of slippage in presentation, a serving face that allows for no cracks, is the ultimate form of success and capital. The houses, while a place of refuge, are also responsible for the coaching of this aspirational excellence, a preparation for facing the harshness of the world with fabulousness—what DJ and theorist madison moore deems "aesthetics of survival."[4]

Here in the *Paris* ballroom, the Black meme is twofold. First, revealing the locality of the ball as a place entirely constructed via the act of Black memesis, this ballroom is shown as a place for the creation of copies of copies that enact "precise replication ... of the styles and behaviors of a range of social types recognizable daily life, from mass-media projections, or from both," and the transmission of this queered Blackness.[5] Secondly, the release of the documentary itself into the mainstream further catalyzed this transmission, initiating a viral sensation of Black gesture and speech into non-Black spaces via GIFs, pop music, and the popular TV series *Pose*, among other localities of digital and visual culture.

In 1991 it was reported that the two-week run initially planned for the film at New York independent cinema house Film Forum had been "extended indefinitely."[6] *Paris Is Burning* brought legendary performers and ballroom icons Dorian Corey, Venus Xtravaganza, Pepper LaBeija, Willi Ninja, and other starry figures of the scene into public ownership and accelerated exchange, but not without questions of equity, representation,

and consent. The language of a queer Blackness as applied and defined in the film—"reading," "shade," "work," "legendary," "fierce," "yassss queen"—entered the global lexicon, introducing (Queer) African American Vernacular English (what I will call here "QAAVE") to a White and non-Black audience and paving the way for the plausibility of the internationally televised drag culture of the 2000s as exemplified by *RuPaul's Drag Race*, which premiered in America in early 2009 and has since endured, transforming into an international franchise. As film critic K. Austin Collins reflects in *Vanity Fair* on the occasion of the film's 2019 limited rerelease, "[For] a queer minority of a certain age who once longed to express yourself and your sexuality in ways that you didn't yet understand ... the film [was] an education."[7]

Still, critical acclaim did not arrive without necessary critique—there was trouble here. Directed by a twenty-nine-year-old Jennie Livingston—who at the time identified as a White lesbian—the creation of the film triggers some very real anxieties about the transmission of a radically queer avantgarde Black and Latinx culture. Most especially tender was Livington's revelation of this private space *into* the mainstream, a space that for many was intended to remain encrypted, a strategic political site of glamorizing, refusal, and resilience.

For some, the ballroom pushed back against the gendered, socioeconomic, and racialized logic of a capitalist culture and therefore was violated when it became transmitted into the commercial mainstream. Drag balls belonged to Harlem and were "the product of a poor, gay and mostly non[W]hite culture," a stark contrast to Livingston as a middle-class graduate of Yale University.[8] Livingston was clumsily quoted saying: "I am educated and I am [W]hite so I have the ability to write those grants and push my little body through whatever door I need to get it through ... If they [the drag community] wanted to make a film about themselves, they would not be able."[9]

Critiquing Livingston's privilege—an outsider to ball culture

documenting Black and Brown bodies and, in doing so, opening queer private spaces for a White public voyeurism—professor bell hooks wrote in her 1992 essay "Is Paris Burning?": "Livingston does not oppose the way hegemonic [W]hiteness 'represents' [B]lackness, but rather assumes an imperial overseeing position that is in no way progressive or counterhegemonic."[10] Filmmaker Isaac Julien raised an eyebrow as well, noting:

> To me, one of the problems in *Paris Is Burning*, is that the subjects in the film are, to an extent, presented to us as objects of a certain gaze that is, in the end, ethnographic. It's a modern ethnographic film set in New York.[11]

In April 1993, critic Jesse Green wrote, for the *New York Times*, "Paris Has Burned"—an article that furthers Julien's position in its description of "drag queens ... on their heels" as "endangered birds." In an uncanny echo of Baldwin's reflection on first seeing Emmett Till ("It was him but it was all of us"[12]), Green quotes Hector Xtravaganza at the memorial for House of Xtravaganza mother Angie Xtravaganza, who died at age twenty-eight of AIDS-related complications: "It's not just her, it's all of them." Green notes:

> There is a lot of anger in the ball world about *Paris Is Burning*. Some of it concerns what a few critics have called exploitation: making the lives of poor [B]lack and Latino people into a commodity for [W]hite consumption.

Yet Dorian Corey, prominently featured in Livingston's film, notably defended the work: "I thought it was something that should have been done ... seeing it was like a fulfillment."[13]

Despite Corey's take, questions of agency and consent within Livingston's process of collaboration continue to be complex. While Livingston noted that "it was largely a gay audience,

Aria Dean, still from Eulogy for a Black Mass, *2017.*
Digital video, 5 min., 54 sec. Courtesy of the artist, Greene
Naftali, New York, and Chateau Shatto, Los Angeles.

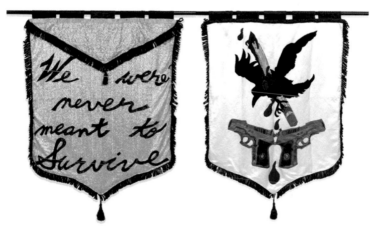

Cauleen Smith, We Were Never Meant to Survive, *2017.*
Recto/verso, satin, poly-satin, wool felt, upholstery, indigo-dyed
silk-rayon velvet, metallic thread, embroidery floss, acrylic fabric
paint, poly-silk tassels, sequins, 72 × 52 in. From the series "In
the Wake," 2017. Courtesy of the artist and Morán Morán.

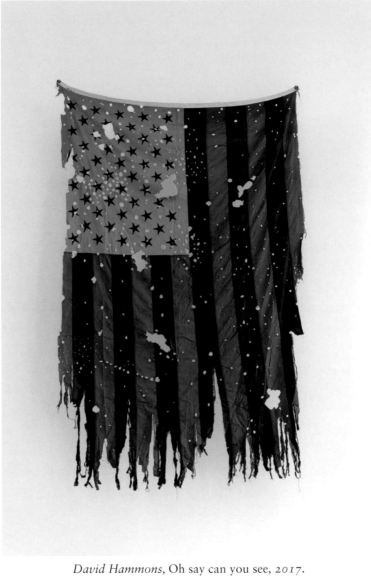

David Hammons, Oh say can you see, *2017.*
Cloth, two metal grommets, 95½ × 60¾ in. Pinault
Collection. © David Hammons. Photo: Aurélien Mole.

Devin Kenny, still from Untitled/Clefa, *2013.*
Performance at Biquini Wax, Mexico City. Courtesy of the artist.

Diamond Stingily, Entryways, 2021.
Door with bat, hardware, 79½ × 32 × 26 in. Courtesy of
the artist and Galerie Isabella Bortolozzi, Berlin.

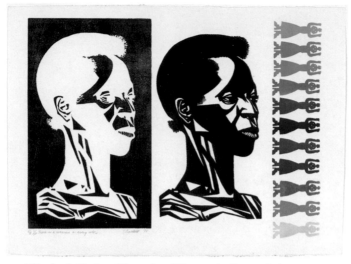

Elizabeth Catlett, There Is a Woman in Every Color, *1975.*
Color linoleum cut, screenprint, and woodcut on Arches
paper, 22¼ × 29 15/16 in. Bowdoin College Museum of
Art, Brunswick, Maine, Museum Purchase, Lloyd O. and
Marjorie Strong Coulter Fund. BCMA Accession#: 2015.61.

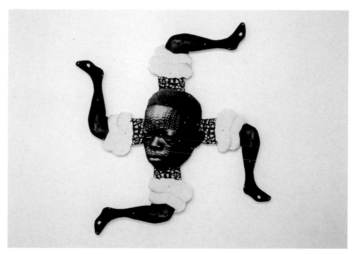

Frida Orupabo, Untitled, *2018.*
Collage: pigment print on acid-free cotton paper, mounting
tape, split pins, 55 × 45 15/16 in. Courtesy of the artist
and Galerie Nordenhake. Photo © Calle Tillberg.

Glenn Ligon, Untitled (Black Like Me), *1992.*
Oil stick and graphite on paper, 23.75 × 21.125 in.
Whitney Museum of American Art, New York;
purchase with funds from the Drawing Committee 93.28.
Photo: Sheldan Collins. © Glenn Ligon; courtesy of the artist;
Hauser & Wirth, New York; Regen Projects, Los Angeles;
Thomas Dane Gallery, London; and Galerie Chantal Crousel, Paris.

Hamishi Farah, Black Lena Dunham, *2020.*
Acrylic on linen, 43¼ × 33 5/8 in. Photo: Tom Bowditch.
Courtesy of the artist and Arcadia Missa, London.

Kahlil Robert Irving

Arches & standards <u>(Stockley ain't the only one)</u> *Meissen Matter*:
<u>STL matter</u>

*Glazed and unglazed ceramic, luster, found and personally constructed
decals, 16 x 16.5 x 15 in (40.6 x 41.9 x 38.1 cm). Courtesy of Kahlil
Robert Irving Studio. [Formatting of title at request of artist.]*

Lauren Halsey, installation view of the eastside of south central los angeles hieroglyph prototype architecture (I), *2022. In "The Roof Garden Commission: Lauren Halsey," The Metropolitan Museum of Art, Iris and B. Gerald Cantor Roof Garden, April 18 – October 22, 2023. Image © The Metropolitan Museum of Art / photo: Hyla Skopitz. Courtesy of the artist; David Kordansky Gallery; and The Metropolitan Museum of Art.*

Mark Bradford, still from Death Drop, 1973 *(1973).*
Single-channel video, no audio, 20-second loop. © *Mark*
Bradford. Courtesy of the artist and Hauser & Wirth.

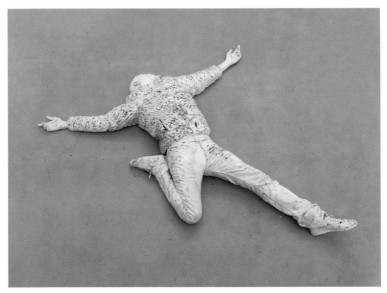

Mark Bradford, Death Drop, 2023 *(2023).*
Mixed media sculpture, 120 × 120 × 20 in. Photo: Sarah Muehlbauer.
© *Mark Bradford. Courtesy of the artist and Hauser & Wirth.*

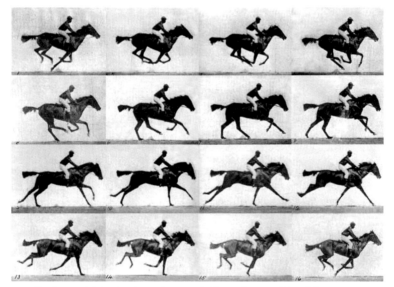

Eadweard Muybridge, Horses. Gallop; thoroughbred bay mare (Annie G) with male rider, *from "Animal locomotion. An electro-photographic investigation of consecutive phases of animal movements,"* 1872–75.

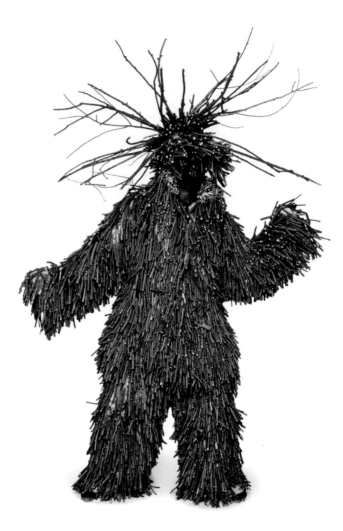

Nick Cave, Soundsuit, *1992.*
Mixed media including twigs, wire, metal, and mannequin,
approx. 96 × 48 × 25 in. © Nick Cave. Courtesy of the
artist and Jack Shainman Gallery, New York.

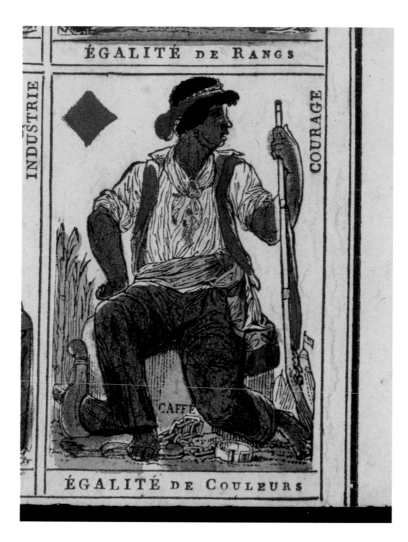

"Courage," design from Nouvelles Cartes de la Republique Française; Poster advertising revolutionary playing cards; published by Jean-Démosthène Dugourc; Paris, 1793.
© *Victoria and Albert Museum, London.*

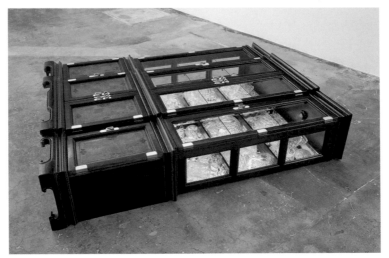

Rhea Dillon, A Caribbean Ossuary, 2022.
Wooden cabinet and cut crystal, 42 × 208 × 161.5 cm. Courtesy
of the artist and Soft Opening, London. Photo: Theo Christelis.

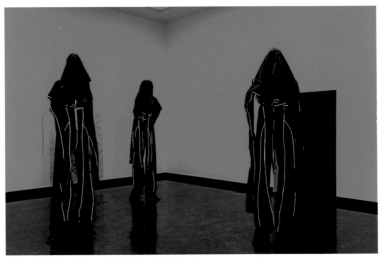

Sandra Mujinga, Nocturnal Kinship, 2018.
Three sculptures, coated PU leather, grommets, polyester, Lycra fabric,
reflecting fabric. Each 270 × 80 × 50 cm. Nasionalmuseet, Oslo.
Exhibition view: Sandra Mujinga. SONW: Shadow of the New Worlds,
Bergen Kunsthall, Bergen, Norway, 2019–20. Photo: Thor Brødreskift.

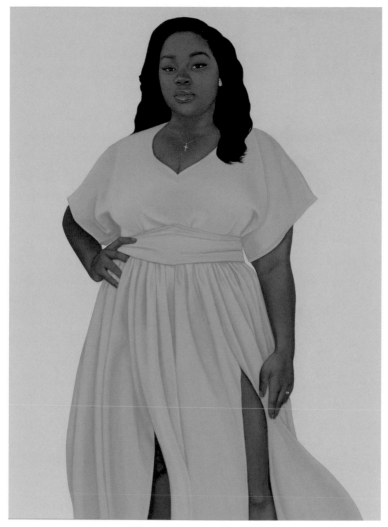

Amy Sherald, Breonna Taylor, *2020.*
Oil on linen, 137.2 × 109.2 cm (54 × 43 in). The Smithsonian
National Museum of African American History and Culture,
purchase made possible by a gift from Kate Capshaw and
Steven Spielberg/The Hearthland Foundation, and the Speed
Art Museum, Louisville, KY, purchase made possible by a
gift from the Ford Foundation. © Amy Sherald. Courtesy of
the artist and Hauser & Wirth. Photo: Joseph Hyde.

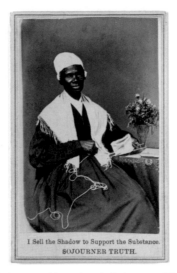

Unknown (American), Sojourner Truth,
"I Sell the Shadow to Support the Substance," 1864.
Albumen silver print from glass negative,
3 3/8 × 2 1/8 in. The Metropolitan Museum of Art,
Purchase, Alfred Stieglitz Society Gifts, 2013.

Lonnie Holley, Copying the Rock, 1995.
Copier, rock, paint, 33.5 × 46 × 24 in. Photo: Stephen Pitkin/
Pitkin Studio. Courtesy of Souls Grown Deep.

which included [B]lacks and Latinos, that made the movie successful," Pepper LaBeija, of the House of LaBeija, described in 1993 the process as she experienced it to the *New York Times*:

> When Jennie first came, we were at a ball, in our fantasy, and she threw papers at us. We didn't read them, because we wanted the attention. We loved being filmed. Later, when she did the interviews, she gave us a couple hundred dollars. But she told us that when the film came out we would be all right. There would be more coming.[14]

LaBeija and many others lived and died with their cultural contributions as viral contributions, but economically unsung. *Paris Is Burning* only took half a million dollars to create, but it grossed $3.8 million in theaters in the US—an impressive feat for a documentary.[15] Many of the performers sought lawsuits against Livingston. Paris Dupree, whose name and annual ball originated the film's title and who is credited as a pioneer of vogue dance, filed suit unsuccessfully for $40 million. The releases they had signed worked against their cause, and by 1991 all claims had been dropped. Livingston was reported thereafter to have paid around $55,000 total, split across thirteen performers.[16]

However contested, *Paris Is Burning* still remains an important document of queer space and family-making. Poet Essex Hemphill, for one, lauded the film as an accomplishment, writing in a 1991 review for the *Guardian*:

> Houses of silk and gabardine are built. Houses of dream and fantasy. Houses that bear the names of their legendary founders ... Houses rise and fall. Legends come and go. To pose is to reach for power while simultaneously holding real powerlessness at bay.[17]

Thus, Hemphill signifies that the "houses" of Black and Brown queerness are established in and perform a spatial "mediat[tion of] ... un/survival."[18] This performance refuses the weaponization of queer bodies of color. It also allows such bodies to take up space, serving new shapes and face without restraint, claiming *rangefulness* that recognizes the embodiment of individual expanse as an ecstatic privilege in its own right.

Performance artist and scholar E. Patrick Johnson writes in his 2003 *Appropriating Blackness*: "Banned from both the public spaces of the heterosexual [B]lack 'home' and the White gay clubs, [B]lack gay men and women create private spaces (the nightclub, another gay person's house, a ball house, etc.) to create community."[19] Johnson underscores that the radical act of redefining home space and claiming nightlife as a site to experiment provides opportunity to explore, dream, and achieve. Ballroom culture, then, makes plain the ecstatic elasticity of Black life looking to reformat, rebuild, restructure, and reenvision.[20]

In further troubling and problematizing the transmission of Black queer culture from private ballroom into mainstream domestic space, we see what happens when a White audience claims or appropriates Black and Brown performance traditions via their personal technologies. It begs the question: What happens when *the queer, Black house* enters *the straight, cisgendered, and/or non-Black home*?

The internet, while offering the potential of being a "house" for many queer people of color as a site of community-building and networked creative expression, has simultaneously provided a "home" to a non-Black audience. Online one can, protected by the enclosure of domesticity, step out in one's social media comments, or repost memes utilizing QAAVE without any recognition or understanding of where it comes from, or of the important history behind it. This transmission of QAAVE away from its site of origin follows a violent colonial tradition. Internet and sound artist Keith Obadike (of the conceptual

88

duo Mendi and Keith Obadike) illustrates the reapplication of Blackness out of context, observing:

> [B]lackness represents some kind of borderless excess, some kind of unchecked expression. Like the commonly confused notion that with African drumming (or … jazz) you just play whatever you feel rather than develop structured content. I would argue that this same kind of romantic freedom is also associated with the net so that [B]lackness and this kind of digital frontier become conflated.[21]

Artist and writer manuel arturo abreu expands on this notion of Blackness as perceived by non-Black people to be a "borderless excess" in their ever-necessary essay "Online Imagined Black English." Citing linguist Cecelia Cutler's theory that "hip-hop is increasingly claimed to be a multi-cultural lifestyle," abreu suggests that non-Black people can enter and exit as they please, trying Blackness on like a newfangled fad diet. In particular, abreu calls out "the phenomenon of non-[B]lack English speakers with no fluency using real or imaginary linguistic features of Black English, which [they call] *imagined Black English*."[22] The QAAVE of *Paris Is Burning* as an early driver of a viral memetic queer-Blackness extends the non-Black fantasy that Cutler proposes and is further challenged by abreu in their essay. Thus queerness—and specifically Black and Brown queerness, as embodied by the proliferation of QAAVE across the digital landscape—is increasingly claimed as a multicultural lifestyle.

In 1979, acclaimed Black American writer James Baldwin, in an essay for the *New York Times* titled "If Black English Isn't a Language, Then Tell Me, What Is?" opined:

> The use, or the status, or the reality, of [B]lack English is rooted in American history and has absolutely nothing to do with … language itself but with the role of language. Language,

incontestably, reveals the speaker. Language, also, far more dubi-
ously, is meant to define the other—and, in this case, the other
is refusing to be defined by a language that has never been able
to recognize him ... It goes without saying, then, that language
is also a political instrument, means, and proof of power. It is
the most vivid and crucial key to identify: It reveals the private
identity, and connects one with, or divorces one from, the larger,
public, or communal identity.[23]

Baldwin's indication of "[B]lack English" as a tool for "use,"
"status," or the remapping of "reality" dictates the language of
Blackness as a "communal identity." The systems and applica-
tions of this are multiple. In *Distributed Blackness: African
American Cybercultures*, interdisciplinary scholar André Brock
Jr. describes how Black Twitter illustrates an "enclaved coun-
terpublic" as a vehicle, "a technical artifact," "a practice," and
"a set of beliefs," each encrypted by a Blackness that, though it
situates itself within public space, is not intended to be decoded
by, or made decipherable to, non-Black audiences.[24]

We see this as well in Fred Moten's reflections on the artist
Jack Whitten and the history of jazz, where he presents Whitten's
idea of "the woodshed" as a Black contribution to the expanded
experimentalism of creative praxis.[25] "Woodshedding," as
Whitten envisioned it within his own artistic practice, is the
practice of delving into the deep-tissue research, exchange, and
practice of a piece of music in private before it enters a more
mainstream public realm.

To bring Brock's "enclaved counterpublic" together with
Whitten's "woodshed," one can then chart a lineage of radical
Black work being done inside of protected spaces. However,
these sites of experimentation are only detectable to those able
to decipher them. Thus, Black Twitter historically has shaped
channels for radical exchange, creation, and critique that are
often hidden in plain sight from a non-Black mainstream audi-
ence or readership.

Another example: Brock suggests that the smartphone is an enclaved "third place."[26] In our context, Brock's smartphone "third place" *is* Whitten's "woodshed," a site for Black cultural production as a networked private space sitting in public view. These spaces for Black people perform as sites of radical criticality and community-building. For this reason, when material produced within the "Black internet" or "queer internet" becomes memetic, it presents a fissure that appears hyperaggressive to audiences enclaved within these "third place[s]." In other words, as the language of Blackness and queerness moves, it can feel like a betrayal of consent, even though this culture of spoken and visual vernacular is publicly accessible and therefore open to the claim of wider ownership and reinterpretation.

The blur between *private* and *public* and the "houses" or "places" asserted therein makes *Paris Is Burning* a particularly strange and contradictory site of viral imagination. In their essay "Keeping It on the Download: The Viral Afterlives of *Paris Is Burning*," gender and sexuality scholar Jih-Fei Cheng argues a counterposition to the virality of Livington's film and the labor enacted by those it narrates. Charting the somatic loss of the living archive of ballroom and voguing culture via the death of many of its originators from the HIV/AIDS crisis that began in the early 1980s, Cheng places this alongside the rise of the personal computer and the early days of the internet, which made technology increasingly accessible to individuals at home.[27] This shift allowed the conversion of *Paris Is Burning* from VHS to other genres of transmissible digital media.

Thus, we see the other side of the coin: Livingston's film has been given a networked platform via the internet. *Paris Is Burning* becomes a document of what Cheng terms "early AIDS media"; the transmission of this material into a hyperpoliced and actively censored visual culture became an urgent intervention. As Collins indicated, the impact of serving as a key "education" and historical roadmap to the innovations of ball culture—and providing an opportunity for afterlives of the

inventors within this history to be resurrected and celebrated
—makes the circulation of this memetic material perhaps a
resistance to the systemic erasure their deaths might typically
be assumed to enact, positing a reality of an everlasting digital
afterlife. Concordantly, Cheng identifies "the gifs, memes and
video clips of Dorian Corey and Pepper LaBeija" in *Paris Is
Burning* as performances against the loss of identity within a
system that is designed to rob them of their selfhood.

Artist Rashaad Newsome comments on the task of renego-
tiating the exposure of queer and Black space as an encrypted
third place, reflecting on "people [like Livingston] outside the
community who came in" and, in doing so, perforated the site
of the ballroom as an enclaved counterpublic in and of itself.
He observes: "Because [voguing] was so co-opted so early in its
creation, and not told from the perspective of the community
where it comes from, there's not the luxury to have it exist only
in the ballroom." Newsome argues that voguing, then, and the
histories of ballroom culture, "should be brought to the masses
but by us," explaining, "the thing about vogue is that it's an
open source."[28]

In this turn, it is important to consider the architecture of
"open source" as laying the groundwork for both a utopian
ideal and a new application of strategic dispossession. While
the term "open source" rose to widespread use in the 1990s in
intersection with the free software movement, it must be said
that the intention of "open source," in its origination, is incon-
sistent with its frequent conflation with "free." After all, shared
information has value, culturally, socially, economically, politi-
cally. Therefore, the "play ethic" surrounding this information,
to borrow media theorist and artist Sandy Stone's term, should
not destabilize the structure of its value.[29] Stone underscores
"computers not only as tools but also as arenas for social
experience."[30] Often, what muddles a discussion of viral value
is the "social experience" component—the idea that a digitally
networked *experience* is inconsistent with its counterpart in the

physical world (e.g., a concert; a sports game, etc.), despite the audience often being many hundreds, thousands, or millions more than might attend an AFK (away from keyboard) event.

Newsome makes an exciting proposition in advocating for a "FUBU" (for us by us) model of viral voguing. Yet, we must complicate this proposal. Most specifically, viewing this gorgeous queer Black *open source* in relation to the histories of property necessitates a restructure of "open source" itself. This is required in order for us to best adapt and respond to the economic vacuums created by the consumptive exploitation of Black and queer people—with or without their consent—on the internet.

How, for example, does the artist get paid? While new technologies offer new audiences, these modes of transmission are often overshadowed by the difficult reality that even now, royalties have been weaponized against queer and Black people. Continuing a sordid legacy of disavowal rooted in the commercialization of Motown, jazz, hip-hop, and beyond, no clear framework has been established to navigate the question of authorship of gesture and language as it moves online.

While discussions of so-called nonfungible tokens (NFTs) as a technology have proposed a short-term solution—that those who have "gone viral" apply the master's tools of capitalist monetization in minting their virality—the exchange around this specific to Black and queer "content creation" remains relatively underdeveloped. For example, emerging dancers and movement "influencers" online, such as American TikTok star and originating author of the viral #RenegadeDance Jalaiah Harmon, rightly voices concern at their work being lifted by White "content creators."[31] At the same time, these dancers legitimately claim that their work popularizes music across a spectrum of performers by pairing their sonic selections to the broadcast of new dance moves. It seems, then, that those like Harmon are doubly overlooked in equitable compensation structures, as the infrastructure of royalties does not allow for

an easy channel of income to be produced tied to the origi-
nating authorship of their dance movements, nor how those
movements heighten visibility and promulgate the economy
around musical compositions that might otherwise remain
lesser seen or known. In 2021, in a move that appeared initially
to be a step in the right direction, TikTok began a partnership
with the blockchain startup streaming platform Audius that
offered a payment structure for musicians.[32] Still, the focus of
this collaboration was first and foremost to apply blockchain
technologies around the virality of songs, not to reimagine a
royalty structure for Black, Brown, and queer movement or
language. *Where to go from here?*

Cinema and media scholar Kara Keeling, in her 2014 essay
"Queer OS," reminds us: "*Queer* offers a way of making
perceptible presently uncommon senses in the interest of pro-
ducing a new commons and/or of proliferating the senses of a
commons already in the making."[33] Perhaps, then, the Black
meme—QAAVE, ball gesture, and all—can learn from Keeling's
proposed "operating system," an opportunity to glitch the
commons of digital space. In doing so, we can enact new models
of empowerment that establish afterlives without the inter-
generational and inherited sacrifice of cultural and economic
divestiture. Artist Glenn Ligon gives us an apt visual for this
turn of refusal: "Miles [Davis] playing with his back to the
audience (also a better position to cue the band from). We're
the band."[34] *Can we be?*

7
REALITY, TELEVISED:
ON THE RODNEY KING
GENERATION

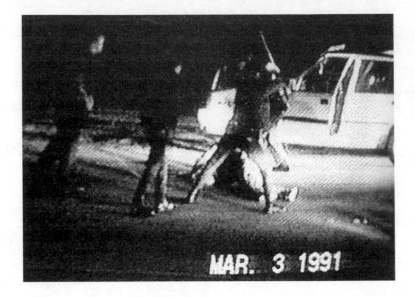

MAR. 3 1991

"You began to read and you were taken back to the moment the video appeared across the Atlantic, transferred by the sturdy boat of the Internet."

—Caleb Azumah Nelson[1]

"[B]lackness is integral to the production of space," writes race and gender scholar Katherine McKittrick in *Demonic Grounds*.[2] Nothing can move without touching Blackness; nothing can move without Blackness as a force, an engine, a technology. Thus, the contemporary circulation in the media of viral material supporting the supremacy of Black social death harks back to the early virality of lynching postcards and the cross-circulation of these images via social media and other digital platforms.

This is demonstrated by such viral acts as "Trayvoning," which came into being in 2012 in response to the murder of Trayvon Martin at the hand of George Zimmerman.[3] In this performance, a person poses for a photograph face down on the ground with a bag of skittles and an Arizona iced tea. These images—often featuring young White people—were distributed via platforms such as Facebook, Twitter, Instagram, and Tumblr. While the trend appears to have been short lived, it remains a visible hashtag on these sites, serving as a key example of the ways in which "digital blackface" continues to shape-shift and perpetuate, taking on new forms within new modes of media.

The fact that Trayvoning predates the 2013 trial of Zimmerman illustrates the ways in which the public, via this disturbing performance, was invested in the forensics of Martin's Blackness. The speculative replay of Martin's death contests and devalues

the teenager's life, establishing a digital town square wherein Martin's lifeless body remains left untended into perpetuity. Further, it asserts a norm for the Black form as fixed, horizontal and motionless: the deceased body stretched out across the ground is determined as a natural state, running counter to a living body that might exist upright, with the capacity to move through the world with agency. As gender studies scholar Kemi Adeyemi puts it: "Being [B]lack and horizontal [is] a spatio-racial coordinate that is threatening" to the White imagination, "as much as it could lead to one becom[ing] [B]lack and upright, which would jumpstart the cycle of killability once more."[4]

In 2013 artist Devin Kenny staged *Untitled/Clefa* in Mexico City, a one-time reperformance of the Trayvoning meme. Kenny, who is Black and American, lay face down on the floor as an audience looked on. He remained there for the duration of the trap song "Versace" by Black American rap group Migos, running for three minutes and twenty-five seconds. The song was then looped three times, with Kenny remaining on the ground for each cycle. Kenny explains, "I wanted to take an image-creating practice that was circulating online, and a) slow it down and b) charge it differently by having it happen in real time." By placing himself, a Black person, at the center of the meme, Kenny creates and holds space for a reflexive relationship between "mimicry and parody."[5] His performance prompts the important question: *Can such reenactment aid the reconciliation of trauma?*

As interdisciplinary scholar Imani Perry reminds us, "a feature of trauma is repetition."[6] The repetitive, viral transmission of Black trauma online today is embodied by Diamond Reynolds's devastating Facebook video showing Minnesota police shooting her partner Philando Castile. When initially posted, it was shared over 32,000 times and generated over a million views.[7] This reaches back and adds profound scale to the murder of fourteen-year-old Black teenager Emmett Till in August 1955, and *Jet* magazine's coverage of Till and his family

later that same year. As images of Black trauma traverse space and time, the technological advances that occur transhistorically accelerate the density of their circulation. With this comes a new reality: a constant resurrection of Black life made undead via endless scrolls and the incessant narration of auto-play.

The repetition continues. On Saturday, March 3, 1991, a White man named George Holliday, the general manager of a plumbing supply company, stepped out onto the balcony of his Los Angeles apartment with a handheld camcorder, filming four officers of the Los Angeles Police Department as they swarmed construction worker Rodney King's prone body with batons and tasers.[8] This video tape of King being severely beaten by the LAPD made visible to many for the first time across the country the extremes of police brutality. As with Selma, the broadcast of King's abuse was significant in its consciousness-raising, signaling a continuation of what had come before—the legacy of state violence, the reality of Black social death—reaching across generations.

King, who was thought to be intoxicated after an evening out with friends, had been driving after midnight and was being pursued by the police. Following a high-speed chase along the highway, King was instructed by the officers to exit his car and told to lie on the ground. Fifteen minutes later, King was left with a broken leg, fractured skull, and severe taser burns. In the negligence claim filed with the city, King noted his injuries as follows: "11 skull fractures, permanent brain damage, broken [bones and teeth], kidney damage [and] emotional and physical trauma."[9]

In the report of the Independent Commission on the LAPD released in 1991, Sergeant Stacey Koon—one of the four officers responsible for the crime of King's assault, and who ultimately served a truncated sentence of thirty months in prison for violating King's civil rights—made an arrest report that was entirely inconsistent with what Holliday witnessed. Koon wrote,

"Several facial cuts due to contact with asphalt. Of a minor nature. A split inner lip. Suspect oblivious to pain."[10]

With King and the officers illuminated by the lights of the patrol cars and the helicopters circling overhead, Holliday and other witnesses to the incident were able to see the truth more clearly. Holliday's tape refused Koon's account, capturing the encounter across twelve excruciating minutes of footage, ninety seconds of which would become known as "The Rodney King Tape."

Holliday sold the tape for $500 (equivalent to $1,072 in 2023) to local news station KTLA. The video traveled across the country, then around the world, often with little credit to its producer. The message in this is devastating: Black life in precarity, a gross commodity for sale, sells cheap but travels fast. Holliday's lawyer James F. Jordan called the tape "the most-played video in the history of this country." Jordan worked on behalf of Holliday to file copyright-infringement lawsuits against news stations and television networks that aired the video without compensating or crediting Holliday for his camera work.[11] In July 2020, at the height of the global resistance in the name of Black lives lost such as Ahmaud Arbery, Breonna Taylor, and George Floyd, Holliday attempted to auction the original camera that he used to take footage.[12] The price was $225,000. (It remains unclear, however, if it ever found a buyer; Holliday died in September 2021 of complications due to COVID-19.)

Reverend Al Sharpton, in 2020, described the tape as "the Jackie Robinson of police videos."[13] The contents of the video have been noted as "among the twentieth century's most recognized images."[14] Holliday went on to market himself as the producer of the "first ever viral video," a bizarre badge of pride in establishing that ninety seconds of tape as the origin point in an era before the internet.[15] This, arguably, paved the way for a future culture of the endlessly exchangeable Black meme as transmitted via YouTube, Facebook Live, Vine, TikTok, and beyond. It was reported that King described to his attorney the

experience of having a sheet put over his head by the LAPD shortly after the assault, prompting King to think he had died. At this moment, King himself, zombified in the eyes of the state, wondered: "If this is what it is being dead, why do I feel this way?"[16] The decision made by the LAPD to place a sheet over King's head underscores Sylvia Wynter's critical analysis of the "No Humans Involved" taxonomy, a dehumanizing action that establishes King in his Black horizontality as no longer a threat, impossible to resurrect upright, and even perhaps signifying that in the eyes of state power he has ceased to exist altogether.

Despite Holliday's footage of King's beating, in April 1992 three of the four police officers involved were acquitted of charges of excessive force, with the fourth case left undecided by the jury. The outcome of the trial launched a citywide uprising across LA as Black and Latinx residents rose in anger at the judgment. The LA uprisings resulted in a surge of arrests, injuries, and deaths, among other losses, setting the stage for what later became known as King's memetic "catchphrase": "Can we all get along?," transmitted widely via TV broadcast in May of that year.

Though King himself was the victim, on March 9, 1993, in the midst of the trial, the *New York Times* made sure to note that King was "No Stranger to Trouble," observing that King had been marked in the trial by the officers' lawyers as "a dangerous, almost superhumanly strong felon, sweating, grunting, violent and impervious to pain."[17] With the trial having commenced a year prior in 1992, Court TV—at that time only eight months old—provided those tuning in "a live, gavel-to-gavel, ringside seat."[18] The burgeoning coverage of the 1990s, inclusive of King's trial, marked a major turning point for Court TV with approximately 8 million subscribers gaining access and ad sales steadily gaining revenue in the multimillions. Founder and CEO of the Courtroom Television Network Steve Brill is quoted in *Variety*, in response to the success of the broadcast of King's trial (into which he edited excerpts of Holliday's video

footage): "Luck is a factor here."[19] Brill's note on the boom of attention in response to King's beating and trial and its generative impact on broadcast revenue emphasizes a disturbing correlation between the hypervisibility of Black social death and the economy it engenders. Executive Vice President of CNN Ed Turner commented of the media moment, "Television used the tape like wallpaper," underscoring the way King's beating, in the regularity of its replay and international circulation, became something of a decorative backdrop, an aestheticized anti-Blackness consumed en masse.[20]

Elizabeth Alexander, in her 1994 essay "'Can You Be BLACK and Look at This?': Reading the Rodney King Video(s)," reflects on how the technology itself mediated differently the experience of collective viewership, as "freeze-framing distorted and dehistoricized the beating."[21] The capacity for the coverage to be recorded, rerecorded, and then replayed external to the site of the initial event itself shaped King's assault, and the coverage of the trial thereafter, as entertainment to loop back on, an entirely different texture than what was typified within the nightly news prior to the technological advances that made this form of broadcast and replay possible. While the simultaneous cross-station screening of coverage in Selma became a unified and shared experience across channels, the reproductive nature of the documentation of King's beating triggered a fractured viewership that splintered across a myriad of platforms, varying in scale.

We see Alexander's "distort[ion]" applied in real time in Holliday's narration of his first and only face-to-face encounter with King. As with the images of Till, it is the abused and distorted Black body that is rendered historic, fixed and final by Holliday's recounting; King as healed and whole is thereby a stranger to the White eye, even that of one who profited from his pain. Holliday recalled:

I looked over and I didn't recognize him because the only pic-
tures I had seen of him were of his face all swollen and beaten
up, but now he'd recovered ... he could tell that I didn't know
who he was, and he said, "You don't know who I am, do you?"
I said, "No."[22]

Today, the feature special can be found on YouTube under
"Court TV—The 'Rodney King' Case"—an opportunity to
auto-play, pause, and fast-forward through the trial, a recir-
culation of an event that makes plain a wound made more
painful by its continued hypervisibility and transmission.[23]

As we reflect on Holliday's wish for fame, financial gain, and
recognition, we must remember the work of seventeen-year-old
Darnella Frazier, whose recording of the murder of George
Floyd in 2020 became viral material and a thread connecting
Till to King to Floyd, the video in its mass replay launching
uprisings of protest across the globe, but created as witness.
While, until his death, Holliday continued to voice frustration
about not receiving his dues for his part in the creation of the
original tape, much to his own surprise, he was included in the
Whitney Biennial in 1993.[24] The tape ran on loop throughout
the exhibition; unlike Schutz's later portrayal of Till, which
prompted public outrage and condemnation, no documented
protests from the public were publicized or reported specific to
the screening of Holliday's tape of King's beating and its inclu-
sion in the Biennial alongside other "art objects" at the time.
The media seemed entirely numb. Critic Deborah Solomon, in
her February 1993 review of the show, seethed:

> The prevailing fashion among younger artists is "martyr art"—
> art that shrieks about every last inequity ... It's as if television
> has replaced art school as the breeding ground for new talent.
> However removed Rodney King may be from the realm of
> esthetics, what's incontestable is that his victim status speaks

directly to the debased spirit of the 90's art world. Martyrdom
—be it political or personal—has found the fast track ... art-
as-group-therapy.[25]

The next month, another critic, Roberta Smith, clumsily
expanded on Solomon's review, seemingly missing the point
herself in her untoward critique of identity politics as a failure
of the Biennial's frame and format:

> The wall labels and texts are rife with fashionable buzzwords:
> identity, difference, otherness. Anita Hill, the Persian Gulf war
> and the violence that followed the Rodney G. King verdict flash
> before the eye, usually on video. In fact, the exhibition makes
> a video artist of George Holliday, the man who was using his
> camcorder for the first time and happened to videotape the
> Los Angeles police beating Mr. King, spontaneously creating a
> document, if not an artwork, that once more brought the issue
> of racism to every American living room. The presence of Mr.
> Holliday's tape signals one of the show's basic flaws, which is
> that it is less about the art of our time than about the times
> themselves.[26]

The media narration that the inclusion of the video of King was
troubled due to it holding a mirror up to "the times themselves"
falls short in truly understanding the problems of having such
a video shown specifically in the forum of a major American
art museum. Speaking to the media, the Whitney's then film
curator John G. Hanhardt illustrated the dilemma and colonial
privilege of the site itself further, proudly claiming the tape's
inclusion in the Biennial: "I knew the videotape was important
the first time I saw it ... It was my choice."[27] Hanhardt's desire
to personally lay claim to the tape as if it were his individual
property is shuddering, aging poorly in retrospect as we reflect
on the moment now. That Hanhardt assumes responsibility not
only for including the video of King in the Biennial but also

for *playing it on loop* says a great deal about who the museum imagined its audience to be at that moment.

Disturbingly, though Rodney King was still alive at that moment, no mention was made of any contribution made to him as the protagonist of Holliday's video. Holliday, however, received a form of compensation: the *Los Angeles Times* reported that the Whitney "made a contribution to Social Reform, Inc., a nonprofit corporation that Holliday set up after the riots and hopes to fund with proceeds from the settlement of a pending suit against KTLA and other broadcasting companies." Whiteness, too, has a third place; in 1993, it was an art institution.

In a paradoxical twist, the Biennial took place only one year before Black American curator Thelma Golden's linchpin exhibition *Black Male: Representations of Masculinity in Contemporary American Art* (1994–1995), also at the Whitney. The exhibition was framed as "controversial" by Charlie Rose in his 1995 dialogue with Golden on his TV show. The twenty-seven-year-old assistant curator, then a rising star at the Whitney—now the renowned director and chief curator of the famed Studio Museum in Harlem—adroitly addressed the intersections of the exhibition, noting acutely, "Film and televised media is so important to our understanding of representation."[28]

The following year, Golden looked back at that moment, writing for *Artforum*: "What would happen if I made an exhibition that completely lived in a world of Black—with a big B—art and artists: uncompromised, unapologetic, uninterested in the mainstream art world?"[29] Elizabeth Alexander's 1994 essay on King, included as a text for Golden's groundbreaking exhibition and its accompanying publication, was thereby transformative, critically charting a path forward for the relationship between representations of Black masculinity in mainstream visual culture, and the complexities of viewership as an asserted dilemma of power and extraction. It shows

how the entanglement of race, class, and gender is important to underscore when considering the precarity of Black life and how this is represented within a discussion of Black virality. In 1992 reporter Paul Reid wrote on King for the *Boston Globe*:

> You saw the grainy black and white images of boots being buried in King's prostrate body. The jury saw frame after slow-motion frame—complete with stop action and zoomed-in close-ups of king's virtual lynching … Just as I can't fight back those photographic images of mutilated Emmett Till … Those and countless other graphic images of the cancer that eats at this nation haunted my boyhood, my teens, and still haunt me today. Now, thanks to a California jury, I have yet another image to file away.[30]

Taken together, these, too, are important early studies of memetic Blackness.

In 2014, Black American journalist John Eligon penned a *New York Times* article addressing the murder of eighteen-year-old Michael Brown by police in Ferguson, Missouri: "Michael Brown, 18, due to be buried on Monday, was no angel, with public records and interviews with friends and family revealing both problems and promise in his young life."[31] Eligon's devastating assessment of Brown as "no angel" makes plain the embedded bias of an anti-Black imagination attempting to grapple with a Black individual's right to live.

Professors João Costa Vargas and Joy A. James, in their essay "Refusing Blackness-as-Victimization: Trayvon Martin and the Black Cyborgs," point out the problem of "presumed innocence," noting that for Black people within a supremacist democratic system it "functions as a probation period," thereby positioning Black bodies (Michael Brown Jr.'s, Trayvon Martin's, Philando Castile's, Emmett Till's) as "liv[ing] on borrowed,

impossible time [wherein] … as soon as the presumed innocence is over … time as a sin-free, threat-free person ends."[32]

Vargas and James note that the "impossible" nature of time, as mapped to a Black life, is largely "because this time is not linear," observing that this lack of linearity makes the span of a Black life one that is "not chronological" but rather "ontological."[33] A Black life is conditioned by a being and becoming *into* Blackness, a selfhood that bends and accelerates time. Social and cultural reads of Black childhood as Black adulthood (an act of reading that is also deeply gendered in its own right) deem a body in Black adulthood as somehow defying space and time, supernatural in its standing outside of logic—even, ultimately, as unworthy of life at all.

Thus, childhood as a construct, one that typically maps public empathy to a "right to life," is reversed entirely. Black children, alive or dead, are read as Black adults. George Zimmerman, as part of his apology to the parents of Trayvon Martin stated: "I did not know how old he was. I thought he was a little bit younger than I am."[34] Zimmerman was thirty years old at the time; Martin was seventeen. A Black individual who has made it to adulthood is read as an inherent threat—exemplified by Rodney King—one that must be stopped, justifying the punishment of physical death. To call on Christina Sharpe, "living in/the wake"—as in, existing in a society that has been shaped, constituted, and conditioned by the legacy of slavery in America—is a constant re/negotiation that "we, Black people, become the *carriers* of terror, terror's embodiment, and not the primary objects of terror's multiple enactments."[35] *In this scenario, is the Black male body even human?*

To better understand why, let us return to philosopher Sylvia Wynter's pioneering essay "No Humans Involved," reflecting on the LAPD classification of "No Humans Involved" (NHI), used to mark crimes against historically marginalized populations.[36] Her letter begins:

You may have heard a radio news report which aired briefly during the days after the jury's acquittal of the policemen in the Rodney King beating case. The report stated that public officials of the judicial system of Los Angeles routinely used the acronym N.H.I. to refer to any case involving a breach of the rights of young Black males who belong to the jobless category of the inner city ghettoes.

She goes on to note: "[These] genocidal effects [prompt] the incarceration and elimination of young Black males by ostensibly normal, and everyday means." Noting that "NHI" serves as a signifier of an invisible caste system, Wynter inquires, "Where did this classification come from?"[37]

The terrifying reading of a living Black body as inherently supernatural means, conversely, that a dead Black body is established as normative. This renders trends of memetic Blackness, like "Trayvoning," as purely performative play, a replication of a normative ideal that in its echo signifies the mollification of "terror's embodiment" within a White fantasy. In her scholarship, Zakiyyah Iman Jackson terms this the "plasticization of [B]lack(end) people."[38] As evidenced in Holliday's "first viral video," the right to a Black life is read as *counterfactual*— quite literally deemed an impossibility. This fiction is advanced through gamifying Black death via memeified material and reading living Black bodies through a cyborgian filter—that is, as othered from the designation of "human." To make play out of pain numbs the reality of physical violence through the physical reenactment.

In its insistence on an assumed Black figure—with Blackness worn as a conceptual skin to achieve the success of the image— prone on the pavement, we see in Trayvoning a continued lineage from King's arrest, where King's relegation to the ground is a preemptive strike against his survival. Holliday's tape thereby becomes almost a form of xeroxing, making copies of a copy, so much so that at a certain point the original image,

saturated in the transmissive act of imitation, is rendered invisible to its carriers, alien in its mutation.

We see this phenomenon played out further in Nana Kwame Adjei-Brenyah's dystopian short story "Zimmer Land," wherein the author imagines an entertainment-park style game, of the same name, that involves cosplay and participatory historical reenactment of the Trayvon Martin shooting. When a patron of the game playing the role of Zimmerman asks, "What is it you're doing here?," suggesting foul play on behalf of Martin in his animated presence, the protagonist, playing the role of Martin, goes sharply off script, responding: "Living."[39]

A vertical life, for the Black meme, is thereby the ultimate offense.

On June 17, 2012, the *New York Times* ran an obituary for Rodney King, after his death was ruled an accidental drowning in his swimming pool at home. The *Los Angeles Times* later reported that "on the pool tile, he had inscribed the dates of both the beating, 3/3/91, and the start of the riots, 4/29/92. He had mulled over marking the wall with another number, of those who died during the riot."[40] He was forty-seven years old. The first line of the obituary reads: "Rodney G. King, whose 1991 videotaped beating by the Los Angeles police became a symbol of the nation's continuing racial tensions."[41] Four years later, on the anniversary of King's LAPD assault, the *Los Angeles Times* ran a headline haunted by Sylvia Wynter's condemnation of the "No Humans Involved" classification: "Rodney King's Daughter Remembers a Human Being, Not a Symbol."[42] Here we are reminded that the transmogrification of *human* into *symbol* as a systemic strategy of dehumanization within the Black meme is one that endures.

8

REFUSING SYMBOLISM: ANITA HILL AND MAGIC JOHNSON

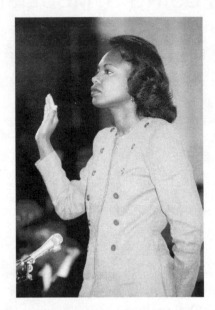

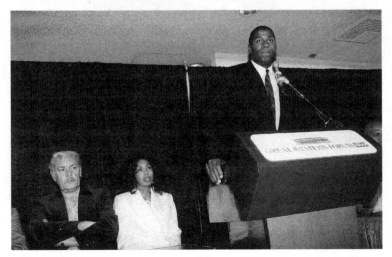

"They have watched television screens that seem to watch back."
—Toni Morrison[1]

The year 1991 remains a watershed for the Black meme. That year saw the LA uprisings, themselves a national forerunner of the October hearing of attorney Anita Hill, who testified that US Supreme Court nominee Clarence Thomas had sexually harassed her some years prior. Then, that November, LA Laker basketball superstar Magic Johnson revealed to the world that he had contracted HIV.

The internationally broadcast Senate Committee hearings with Dr. Hill and Thomas that occurred from October 11 to 14, and the coverage that followed, ran alongside—and intersected with—Johnson's televised announcement on November 7. These moments, and the tectonic shifts they represented, became a complex negotiation of the state of Black cultural icons. Each figure as an icon is pulled between the *symbolism of Blackness*, pitted in opposition to the *humanity of Blackness*, in addition to *Blackness-as-signifier*. Setting into motion a framework for televised testimony and narrative confession that places the realm of the private into public view via a dramatized broadcast, both Hill and Johnson, in their navigation of the spotlight, illustrate the ways in which Blackness labors, with and without consent.

What does it mean to embody an icon? Dr. Nicole Fleetwood, in *Racial Icons*, determines: "We ... fixate on certain images of race and nation, specifically the [B]lack icon." She expands on this, observing, "Racial icons, especially in the realm of social and political movements, make us want to *do* something. These images impact us with such emotional force that we are

compelled: to do, to feel, to see."[2] Thus the *Black meme* and the question of the *Black icon* are inextricably bound up within one another.

Icons are sites of projection and, in large part, sites of fantasy. To *become an icon* allows for an extension, transference, and transmission of affect that lends permission to *step into a body*. The body then becomes an architecture for playing out different social or cultural tropes. Today, as we follow the discourse of digital blackface in relation to the circulation and oversaturation of Black GIFs and memes, we track new modes of iconographic reverence and auto-replay that operate as prosthetics to the limitations of one's race, class, sexuality, or gender. Black icons are thereby critical to the Black meme, a necessary elevation of the ordinary to the extraordinary. It is a quasi-spiritualism that transforms figures, flawed in their everyday humanity, into simultaneous saints and martyrs.

The process of *becoming an icon* in its transformation elevates a Blackness that is often determined subhuman and thereby marginal or alien, with a Blackness that is superhuman in how it is idolized and worshiped. To invoke Doreen St. Felix's 2014 tweet: "everybody wanna be a [B]lack woman but nobody wanna be a [B]lack woman." St. Felix here makes known the dilemma of Blackness within a culture shaped in its systems and visual culture by anti-Blackness; the investment in creating icons of a Black everyday is in direct contradiction to the ongoing violence against Black people in their lived experience.

The casting of Hill and Thomas as iconic figures in the media is a critical component of grappling with this tension. In her testimony of her alleged sexual harassment at the hands of the future Supreme Court judge, Professor Hill stood up bravely to do the work that has since become the blueprint for White women such as Monica Lewinsky, Christine Blasey Ford, and even Amber Heard, all of whom lodged impactful public accusations of sexual assault or misconduct by powerful men. The image of Hill as she took an oath of sworn testimony before

the US Senate Judiciary Committee is indelible: Hill, right hand raised, is in a blue suit with fuchsia lipstick and permed hair. On C-SPAN's YouTube channel, under "October 11, 1991: Anita Hill Full Opening Statement (C-SPAN)," comments continue to be posted in support of Hill as the public returns to the coverage of the time. One commenter observes, "I believe she was testifying the truth! I remember this very well"; another, "She is believable, and I believe her."[3]

Fifteen years before Black American activist and sexual assault survivor Tarana Burke first posted the hashtag #MeToo to social media, Hill set the stage for the urgent dialogue surrounding the belief in women's accounts of gender violence. Burke's #MeToo was co-opted in 2017 and made a viral sensation by White American actor Alyssa Milano—and the many female celebrities who thereafter spoke out on Twitter and other platforms about their experiences of abuse at the hands of now-convicted sex offender Harvey Weinstein. Following that, the rise of #BelieveWomen accelerated in its viral circulation in response to the nomination of Brett Kavanaugh to the Supreme Court in 2018, as Kavanaugh was accused by Professor Ford of sexual assault.

Still, it was in 1991, via the Thomas and Hill hearings, that "believ[ing] her" was first posed as a critical question. Hill's nationally televised testimony, spoken in front of an entirely male Senate Judiciary Committee, was the center of national attention. While the hearings themselves did not significantly shift public opinion about Thomas (58 percent of Americans at the time supported his confirmation), the broadcast put language to the experience of sexual harassment and gender violence that paved the way to the expansion of dialogue on the need for systemic change in the protections of women through and beyond the American workplace. This shift was further evidenced by the passing of the Civil Rights Act of 1991, which expanded women's rights to sue and seek damages for discrimination and harassment, sexual or otherwise. As played

out on a loop across the media, the hearing and the forum that rose up around it was less about who Hill and Thomas were as *human beings*—if, as a Black woman and Black man, they could even be perceived as fully human by those looking on— as about what they symbolized within a cultural framework. Here, too, devastatingly, there were "No Humans Involved."

This battle was part of a wider context: the struggle for, as critic Hortense Spillers terms it in her essay of the same name, "the idea of Black culture" and what it proposes, performs as, or represents. In 1991, renowned theorist and educator bell hooks, in conversation with filmmaker Isaac Julien, noted how Blackness functions as a filmic agent: "Blackness as a sign is never enough. What does that subject do, how does it act, how does it think politically?" Professor hooks keeps it real: "Being [B]lack isn't really good enough for me: I want to know what your cultural politics are."[4]

The forum of "cultural politics" in relation to the acts of sexual harassment Hill detailed in her testimony, though hyper-visible in its media, was not necessarily established as hyper-real. While the broadcast of Hill's testimony shifted the American public opinion in favor of Hill from 26 to 44 percent (with favor toward Thomas dropping in percentage from 48 to 44 percent thereafter) it also shaped a theatrical narrative arc that positioned Hill in the spotlight of immense spectacle and critique. If through the very nature of *being Black* one *is determined as spectacle*, perhaps, then, there is no distinction, as the distinction is collapsed with the goal of making Blackness always in performance, never allowed to be at rest. To call on political scientist and Black studies scholar Cedric Robinson: "Black people are products of the modern world."[5] Professor Hill and Thomas, then, are products of this modernity too; Blackened by their being packaged, politicized, televised, transmitted, and consumed.

Without the framing of media technology, a "modern Blackness" becomes a near impossibility as a cultural construction;

indeed the Black meme serves as an agent of its mechanical reproduction and iconic recirculation. If culture is, as philosopher Herbert Marcuse argued in his 1965 essay "Remarks on a Redefinition of Culture," a "process of *humanization*, characterized by the collective effort to protect human life," then Black culture automatically creates a dilemma.[6] Hill and Thomas, throughout the hearings, stepped into an exercise of framing and imaging that brought into non-Black everyday viewership a multivalent perspective on Black "human life." This reframing, like Rodney King's viral video, surfaced triggering intersections of race, class, and gender in ways that had never been experienced so widely in American households, challenging assumptions about what "protect[ion]" should look like.

If the tape of Rodney King's beating established a new form of surveillance, and a new application of machinic technologies, Hill and Thomas—and Magic Johnson, as he followed on their heels in the news a month later—were transformed into archetypes of upwardly mobile Black life who, despite their class ascension, could not escape the reality of social death and its impact. Professor of film and media Jared Sexton writes, "Black life is not lived in the world that the world lives in, but it is lived underground, in outer space."[7] The King video heralded into being a visualized Black "underground" surging in the rebellion that followed his assault. This was a revelation to non-Black spectators, a showing of the emotional frequency of Blackness as a wild and potentially catastrophic force when collectivized against the state. Conversely, Hill and Thomas turned "outer space" inside out. As it was televised across four days, an unprecedented viewership put a face and voice to gender violence that to this point had failed to be pronounced within mainstream media.

Just under 30 million homes—approximately 30 percent of those with television in America at that time—watched Hill's hearing.[8] The challenge, however, was the failure of what

theorists Kodwo Eshun and Dr. Ros Gray cite as insistent and "militant imag[ing]": there was no viral tape of what had occurred that could evidence Professor Hill's testimony completely.[9] The viral material, then, was the broadcast itself, with the capacity for its replay made possible with the rise of platforms such as YouTube. The plausibility of the hearings and their testimony, for both Hill and Thomas—and, via extension, the US Senate Committee—hinged upon their ability *to successfully image their complaints*. This became an exercise of who would win the imagination not only of the committee but of those watching at home.

On this occasion, the home space merged with the state, enacting a sort of perp walk of Professor Hill,

> a moment for [the] public, all at once audience and witness, to seize authority, participating in a dialogue that otherwise they might be excluded from, and, once and for all, to strip the accused of whatever moral authority they may have previously held.[10]

In this way, Professor Hill experienced what French critic and essay Roland Barthes calls a "death of author[ship]" of her own story.[11] Her narration became something other than her own account: a composite of public interpretation, historical projection as inscribed onto her personhood and nationally choreographed.

In this moment, sexual harassment and violence in the workplace saw a new viral form of expression. The dimensionless and filmic screening of Professor Hill and Thomas on TV via their "split-image freeze frame" seeded new visual language for televised broadcasts of national news that, in their transfer into the home, blurred the line between *private* and *public*.[12] Through the antagonistic and fetishized cycle of "ritual, repetition, and reproduction," Professor Hill's recited testimony in response to the invasive questions that were posed to her became theater,

with America and the world as a captive audience.[13] For Black women, it laid bare the structures of violence that follow them across both private and public space. Thomas's denial of Hill's lived experience was a pronounced alignment with the violent structures of power manufactured by Whiteness.

Thomas weaponizes this invasive interrogation of Professor Hill as a strategic tool in advancing his own ascendancy—one that parasitically invested itself in its proximity to Whiteness as a host and survival mechanism. This was, as writer Toni Morrison reminds us in her essay on the 1991 hearings, a "site of the exorcism ... situated in the miasma of [B]lack life and inscribed on the bodies of [B]lack people," exorcizing and bringing to the fore the deep-seated and sadistic consumption of Blackness under the gaze of Whiteness.[14] Literary scholar Vincent Woodard queries tenderly: "How does it feel to be an edible, consumed object ... how does it feel to be an energy source and foodstuff, to be consumed on the levels of body, sex, psyche and soul?"[15]

Thomas's closing statement noted that "this is not a closed room"—an inscription of the site as a stage, rather than the closed rooms where Professor Hill testified he had harassed her, the events transforming the room into a national theater. Recall Imani Perry's proposal of repetition as a prerequisite of trauma. The writer and critic James A. Snead tells it straight, offering another dimension: "Black culture highlights the observance of ... repetition."[16] This argument suggests repetition itself is a requirement of Black material, a way in which culture is kept alive, archived, revivified. Revisiting Hill's testimony allows for the filmic loops of televised testimony to reverberate in their repetition—in Hill's raising of her hand in 1991, we see Lewinsky's raising of her own in 1998, and Ford's in 2018. These repetitions remind us painfully of gender violence as an endemic trouble while exalting the tireless labor of Black womanhood and the pathways Hill herself set forward to make such fora possible for next generations.

Thus, the Black meme shaped by Hill and Thomas enacts this repetition as a form of preservation and memory-making, stitching together moments across a collective history. When Thomas then dubs the hearing as a "high-tech lynching" in his final statement, he reveals two things: first, the awareness of technology as being essential to the production of the spectacle in which he finds himself; and second, the instrumentalization of lynching as a key gear within a national algorithm, drawing a line between him and the visual culture established by the likes of D. W. Griffith's malignant *Birth of a Nation* and the mob executions of Thomas Shipp, Abram Smith, and Emmett Till, already networked into the American consciousness. By conflating the broadcast with the act of lynching, Thomas flips a paradoxical but forceful lever of both dispossession and power, situating himself inside of loop that has existed since the invention of Blackness. He reconstructs himself out of a myth, his strategy zombified: a dead body, now reanimated and repossessed in its suggestion of humanity, broadcast to 30 million homes.

Over three decades later, the engagement of technology as a breaking and remaking of the American algorithm is remixed and revisualized by the publics of the internet. In 2016 American actor Kerry Washington played the part of Anita Hill within the HBO made-for-TV film *Confirmation*, which dramatizes the hearings and the sequence of events at the 1991 hearings. Today, when one searches for "Anita Hill" as a GIF, the only results that surface are of Washington—no trace of the actual form of Anita Hill herself—and notably, numerous memes feature Washington as Hill rising to stand, presumably right before she is sworn in under oath.

A search for "Clarence Thomas" yields something different entirely: images of Thomas himself, the first in line captioned with Thomas's now-famous turn of phrase from his preliminary September 1991 Supreme Court confirmation hearings, which predated Hill's hearing, wherein he states, "I have no agenda,"

in response to a line of questioning surrounding his position on abortion as a critical issue within the politic of reproductive rights. Thus Hill is silently fictionalized, mythologized, and made iconographic via the consumptive engine of American celebrity, while Thomas continues to be provided a voice via the text engaged as captions beneath his own physical form.

In May 2020—just months after much of the United States experienced its first shutdown as a result of the global COVID-19 pandemic, and only two days after the murder of George Floyd by Minneapolis Police officer Derek Chauvin—artist, opera singer, and composer Li Harris published on her website "A Performer's Response to Dead Performance Online."[17] Harris wrote: "I will not share my Life performance in the same space that Death performance is being created, distributed and consumed. As long as Black bodies are being forced to perform dead online, I will not be performing live online."[18] In many ways, this declaration marked a clear and active refusal of the onslaught of requests on behalf of academic and creative institutions worldwide for artists to make "content" of their culture-work in performing and enacting their creative labor on the internet.

While "life performance" produced through and for digital space—such as that of the now-renowned dancer Jalaiah Harmon, whose "Renegade Dance" went viral, first on an app called Funimate and then via Instagram in 2019—the moment Harris's post was shared was a particular turning point.[19] Harris's words in defense of Black life and the refusal of Black death on autoplay ring out tenderly as we turn now to Magic Johnson's November 7, 1991, announcement of his retirement from the LA Lakers, on the occasion of his testing positive for HIV.[20]

The Centers for Disease Control and Prevention reports that in 1991, "29,850 U.S. residents died from HIV infection; of these, 3% were aged less than 25 years; 74%, 25–44 years;

and 23%, greater than or equal to 45 years."²¹ Given the gaps in reporting due to the stigmatization of the virus, this is likely only a partial representation of the fuller impact of HIV/AIDS as it emerged from the 1980s and surged into the 1990s. Thus, it was exceptional in the moment that Johnson made this news. To date there had yet to be a visible representation of HIV/AIDS that was all at once sick, Black, straight, cisgendered, famous, and wealthy. It was an impossible, near-mythological combination. Again, to return to Sun Ra's reminder: "You're not real."

This was a moment that shifted all of that; suddenly Johnson transformed into a body carrying thousands of bodies in pain, bodies in erasure, all very real. The basketball star's announcement can be read as (to call on Harris's terminology) "death performance" and inherently necropolitical.²² However, beyond the announcement, Johnson made the choice to take a stand for so many who would never receive such a forum.

Artist and writer Johanna Hedva notes the "the trauma of not being seen," foregrounding the question of "who is allowed in to the public space, of who's in charge of the public."²³ A sick Black body at a press conference filled with majority White spectators, Johnson's willingness *to be seen* makes the impact of his visibility both sacrificial and strategic. In retiring from basketball, Johnson established a protective enclosure for himself. As we saw with Professor Hill's testimony, which made plain "private acts" as they occurred in "public space," Johnson, via his public disclosure of his private condition, collapsed the relationship between the private and public realms.

As Jennie Livingston's *Paris Is Burning* entered the mainstream only a year before, it had barely engaged HIV/AIDS as a subject despite it having a devastating impact on ballroom communities. With the volatile backdrop of the increased controversies of conservatism and censorship spanning the 1990s, as initiated and sustained by publicly funded state entities such as the National Endowment for the Arts, Livingston and her distributors would likely have been aware of how a focus on the

impact of the AIDS epidemic might have made vulnerable the marketability within the mainstream—and, by extension, the virality—of the film overall to funders and audiences external to the community it depicted. This is in opposition to, for example, the American TV series *Pose* that debuted decades later in 2018, wherein HIV/AIDS is placed at the center of the ballroom, critical to its narrative arc across episodes.

We can therefore read Johnson's decision to come forward to talk about how he had discovered his own exposure to the virus through the process of setting up his life insurance—how Johnson discovered his test results—as seismic. Tellingly, condom sales skyrocketed as a consequence of the announcement.[24] Johnson, despite contracting the virus, makes plain his economic and social privilege, declaring, "Life is going to go on for me, and I am going to be a happy man." Still, importantly, his admission exposed toxic class assumptions: "I think we sometimes think only gay people can get it; it's not going to happen to me ... I am saying that it can happen to anybody, even me, Magic Johnson."[25]

His work continued. Johnson was quickly co-opted by the national theater of American politics, turning him from sports icon to mouthpiece and political symbol. He refused to accept the objectification. Ten months later, in September 1992, Johnson resigned from the National Commission on AIDS, writing to then President George H. W. Bush: "I cannot in good conscience continue to serve on a commission whose important work is so utterly ignored by your Administration."[26] This was Johnson's pronounced rejection of becoming a symbol. In the midst of a presidency genocidal in its negligence, responsible for the violent failure and erasure of the people and bodies impacted by the HIV/AIDS epidemic, his refusal to accept his own instrumentalization by the state was a profound statement.[27]

Today, Johnson's announcement, forever memorialized on YouTube, just keeps playing on.

9
"THE DANCING BABY": BIRTH OF A [GIF] NATION

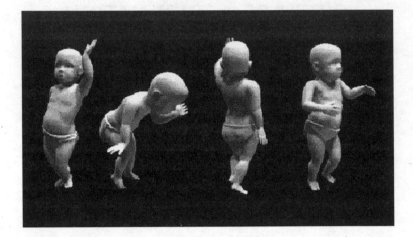

"It's sad to see how much of the Black death spectacle is also the Black entertainment vehicle is also the Black celebrity vehicle is also the Black abstraction [vehicle]."

—Kandis Williams[1]

What are the questions of labor when a body, forever memorialized via the endless archive of a digital scroll, is kept in constant motion? It is impossible to talk about this history and its complicated relationship with the transmission of Black(ened) affect without revisiting the "first digital meme"— the "Dancing Baby," also known as "Baby Cha-Cha,"[2] which rose into viral fame in 1996. Before there was the language of "digital blackface," there was the viral sensation of the Dancing Baby. This was the ultimate expression of roboticist Masahiro Mori's 1970 theory of *bukimi no tani genshō*, translated in 1978 by critic and curator Jasia Reichardt as the "uncanny valley." Mori's uncanny valley described the sensation prompted by the replication of human characteristics that come close to appearing "real" but perhaps in some ways fall short, triggering a reaction of uneasiness or discomfort.

When we grapple with the architecture of the GIF today and how this material moves through time and space, we are wrestling with this infant figure as its genesis. Though much has been written about the Dancing Baby's contributions to the arc of digital animation and what we now know as the viral GIF, it remains surprising that to date there has been little to no critical discussion or critique of this early GIF as undoubtedly raced material, a blueprint designed by White creators. Reframing the originating contributors to models

of minstrelsy in cyberspace, we must remember that within the memory of the internet, there is, in fact, an origin point: an imaginary projection of a Black child who dances for the viewer on loop, in endless labor. Discussing how viral culture is codependent on the presence of Blackness, artist Kandis Williams observes, "This is American entertainment, and it's always been laughing at singing, dancing, dying slaves."[3] The Dancing Baby reveals the relationship between Blackness and Black childhood as engineered for entertainment and, stripped of its agency, made property to whomever is on the sending or receiving end of the file.

What filmmaker and cultural critic Hito Steyerl terms "circulationism" here is, as she reminds us, "not about the art of making an image, but of postproducing, launching, and accelerating it."[4] To have Black childhood made into an animated talisman, souvenir, or plaything shifts the responsibility of the GIF as a realistic image worthy of empathy or care.[5] Thus, the very nature of its impossibility, via its never-ending movement, strips away the possibility of the Dancing Baby being read as human at all. The capacity for the body to move without faltering, devoid of any suggestion of strain despite its continued action, establishes the figure as being beyond-human, cyborgian, or extra-human. The uneasiness experienced, then, is not solely enacted by the figure approximating humanity but, in fact, by its ability to transcend it, as an entertainer that refuses the human need to pause and refresh but instead lives beyond mortal instinct or desire.

To Steyerl's very point, this first GIF was built to be postproduced, launched, and accelerated. Its entire being was an exercise of learning about how a bodily image could be transmitted by a public, and at what speed. In 1996, the man credited as the primary creator of the Dancing Baby, Michael Girard, was running his own 3D-animation company, Unreal Pictures in California. Girard, along with his team, conceived of the idea originally as an experiment, to test out the application of

different types of data and files within an animation software product called "Character Studio," used along with a product called 3D Studio Max. As such, the original file for the dancing baby was called *sk_baby.max*. Both "Character Studio" and 3D Studio Max are products from a company called Autodesk, a multinational company, founded in 1982, that is best known for the AutoCAD design software.

When the 3D source file as a video animation was released to the public, users were able to create their own video clips of the original Dancing Baby and circulate these copies across digital forums. Given that the data of the file was shared as open source, people were able to download and distribute it royalty-free. In late 1996 a web developer named John Woodell managed to create a highly compressed animated GIF from the original source video animation. Further compressed, the Dancing Baby very quickly proliferated, its virality becoming an international sensation that appeared online and on broadcast television. Girard—who referred to the Dancing Baby in news coverage as a "biped," an evolutionary term typically used to describe an animal, as opposed to a human, that walks on two legs—in reflecting on this period of time, notes:[6]

> I think it spread because the file was a GIF you could easily attach to emails, and the baby seemed carefree and optimistic. But mostly, and kind of disturbingly, people enjoyed ridiculing it. I wanted my work to be taken seriously: I'd previously studied human motion with top choreographers. This baby was far less graceful and artistic; it was just a little uncanny-valley GIF … [but] the exposure was great for my company.[7]

In its mass circulation, the GIF became a souvenir—with devastating parallels to what cultural historian Harvey Young terms "the lynching keepsake"—the cutting of physical parts of Black people away from their bodies after their death as a memento. In his 2005 essay "The Black Body as Souvenir,"

Young traces the word "souvenir" to the Latin *subvenire*, meaning "to come to the mind"; he notes that the word, in both noun and verb form, serves a "memorial function." Young then breaks these events into three parts—"the souvenir, the fetish, and the performance"—observing further, "the body part recalls and remembers the performance of which it is a part. It not only gestures toward the beliefs that motivated its theft, but also renders visible the body from which it was taken."[8]

In addition to holding the title of being the first GIF, the tireless performance of its labor offers another racial reading. "Baby Cha-Cha"—though the name indicates otherwise—is not, in fact, doing the cha-cha at all. To provide some historical context, the footwork pattern of *cha-cha-chá* (*one, two, three, cha-cha*) draws its influence from Afro-Cuban dance.[9] The Afro-Cuban dance movement, which traveled to the United States from Cuba in the 1950s, predates the ever-popular dance now often seen in media broadcast: "the cha-cha." Thus *the cha-cha* as a form of dance draws from an Afro-Latinx tradition.

The naming of this baby as "Cha-Cha" underscores that the creation of this figure, not rendered from life, hails from a fetishized White imagination of fictive Black movement. Girard's recognition that he had "studied human motion with top choreographers" makes plain the immense gap in understanding of the true history and accurate representation of "cha-cha" as a dance. This racialized digital skin expands the viral transmission of the Dancing Baby through popular culture, becoming a performance of a performance, an uncanny souvenir in its own right.

Complicating things further, the video animation in the 1990s was subsequently set to the 1974 Blue Swede cover of the song "Hooked on a Feeling," originally a hit by English songwriter Jonathan King that was, in arrangement, inspired by a 1971 recording by an all-Black Jamaican reggae band, the Twinkle Brothers. In the Blue Swede cover, one can hear a chanted

"ooga chaka," which, in a deeply troubled gesture of minstrelsy, performs the European fantasy of Indigenous vernacular.

In a bizarre twist, this Black baby, accompanied by the Blue Swede soundtrack, was later featured on an episode of the popular American TV show "Ally McBeal" titled "Cro-Magnon," wherein the baby became a recurring hallucination of the show's protagonist.[10] This marked the Dancing Baby, as one observer notes, as "one of the first virtual characters to make the leap from the World Wide Web to prime-time television."[11] Now bound to the song, the animation thereafter became known as the "Oogachaka Baby." Since then, the meme has itself been transformed by the public into new versions—"samurai baby" and "rasta baby," to name a few—each deepening as a racialized replica, a copy of a copy, a souvenir of the original, all still dancing into perpetuity—seemingly carefree, as Girard hoped, but also as the object of public ridicule. To bring Lauren Michele Jackson's words back into the room from the start of our journey: "What is the half-life of a meme? What is the rate at which a good-natured meme decays into the grossest displays [of] public ridicule?" Writing through time, decades prior, French sociologist Jean Baudrillard mused forward to meet Jackson's query: "Is the simulator sick or not, given that he produces 'true' symptoms?"[12]

10

THE SHADOW, THE SUBSTANCE: RENTY AND DELIA AS VIRAL DAGUERREOTYPES

"Does a [W]hite meme admin have any business posting an image of a [B]lack person? Are they laughing with or at us? Are they capable of laughing with us? Has my Explore feed been gentrified?"

—Aria Dean[1]

"I SELL THE SHADOW TO SUPPORT THE SUBSTANCE."

—Sojourner Truth[2]

The first page of Tamara Lanier's 2019 complaint against Harvard begins with the following quote and five points:

"History, despite its wrenching pain, cannot be unlived, but if faced with courage, need not be lived again."

—Dr. Maya Angelou, *On the Pulse of Morning*

1. The plaintiff, Tamara Lanier, brings this action against Harvard for its wrongful seizure, possession and expropriation of photographic images of the patriarch of her family—a man known as Renty—and his daughter, Delia, both of whom were enslaved in South Carolina.

2. The images, known as daguerreotypes, were commissioned in 1850 by Harvard's leading scientist, Louis Agassiz, as part of his quest to "prove" [B]lack people's inherent biological inferiority and thereby justify their subjugation, exploitation, and segregation.

3. At Agassiz's behest, Renty and Delia were stripped naked and forced to pose for the daguerreotypes without consent, dignity, or compensation.

4. Responsibility for that crime lies squarely with Harvard, which elevated Agassiz to the highest echelons of academia and steadfastly supported him as he prompted and legitimized the poisonous myth of [W]hite superiority.

5. Harvard has never reckoned with that grotesque chapter in its history, let alone atoned for it.[3]

Lanier's lawsuit, filed as a descendant of Renty, was first filed in 2019. She had first found the images of Renty on the internet in 2011.[4] Lanier had been searching to learn more about her family history and genealogy, and it was through her research that she landed on the photographs, which were still held by Harvard University.

The story of Renty's and Delia's images arcs further back: uncovered by curator Elinor Reichlin in 1976, the photographs had been tucked away in the attic of Harvard's Peabody Museum of Anthropology, originating from a studio in South Carolina in 1850.[5] Reichlin's discovery of these photographs was particularly significant because they are believed to be the first images captured of enslaved people.

At the time, the Swiss-born American professor Louis Agassiz was considered a leading thinker in the study of natural history. Friends with the likes of Darwin and Galton—both of whom espoused views aligned with eugenics and scientific racism—Agassiz had emigrated to America in 1847 and thereafter was a professor of zoology and geology at Harvard. Agassiz was also a strong proponent of the virulent "polygene" theory that was used to advance the argument of White racial dominance. As a result of his research, he had commissioned the photographs of Renty and Delia, two enslaved people, from Joseph T. Zealy, a photographer trained in society portraiture. Agassiz viewed both images and the sitters as specimens of his research. A 2020 *New York Times* article reflecting on this history observes Zealy's methods of imaging: "He carried on … using the same light, the same angles, giving the images their unsettling, formal perfection."[6]

In 1850, when the images were produced, the photographs were deemed property of Agassiz; in contrast, Lanier's search for legal recourse and restitution, 170 years later, was intended as a reparative act. It was an opportunity to refuse the anti-Black structure of ownership and property-making, putting forward a case that argued the coercion of Renty and Delia, her kin, whose participation in the images could not and should not be read as consensual. In her lawsuit Lanier "alleges that the images of Renty and Delia are still working for the university, based on the licensing fees their images command."[7] While the original prints have not gone on loan from the institution of Harvard since 2002, Harvard has quietly abandoned the copyright claims to them. In 1996 Harvard threatened artist Carrie Mae Weems with legal action for using photographs commissioned by Agassiz in her series *From Here I Saw What Happened and I Cried* (1995). Weems reflected on this work, noting, "I wanted to intervene in that by giving a voice to a subject that historically has had no voice."[8] The case never reached the courts, as Harvard ended up agreeing to a fee for each work sold, which the university then used to make an acquisition purchase of the series for its collection.[9] Today, all the Agassiz daguerreotypes exist in the public domain.[10] For a fifteen-dollar fee, any member of the public can access a scan at high resolution.

A simple Google search yields a density of results; Renty and Delia both have gone viral. Lanier has commented: "From slavery to where we are today, Black people's property has been taken from them ... We are a disinherited people."[11] Journalist Latria Graham underscores this, noting, "[Lanier's] fight is an important front in a war over the ownership of images of Black bodies, one that is being waged on TikTok as well as in dusty archival drawers." She further asks, "Will the Black body ever have the opportunity to rest in peace?"[12]

The legal team that joined Lanier in her defense as she took Harvard to court in 2019 included Ben Crump, who represented the families of Trayvon Martin, George Floyd, and, later,

Breonna Taylor. Lanier accused Harvard of "wrongful seizure, possession and expropriation."[13] Forty-three of Agassiz's direct descendants signed a letter in support of Lanier's claim that inquired: "Does the University want to continue to gain from an image stolen from enslaved people?"[14] Nonetheless, the case was dismissed by the court.

The "current legal principles" used by Justice Camille Sarrouf to dismiss the case in Middlesex County Superior Court derived from exactly the same legal framework that, across centuries, stripped Black Americans of the right to equal representation, alongside any claim to physical and cultural property.[15] This, in the words of Lanier, "perpetuate[s] the systemic subversion of [B]lack property rights that began during slavery and continued … thereafter."[16] Sarrouf determined in her decision, "The law as it currently stands, does not confer a property interest to the subject of a photograph regardless of how objectionable the photograph's origins may be."[17] In a statement released before the March 2021 dismissal, Crump commented on the importance of establishing legal precedent for Black people in terms of questions of ownership, underscoring what was at stake, "This will become a legal mandate for all of those Black people … to be able to recover whatever artifacts, relics, artwork—anything of significance or value that was seized from them during slavery."[18]

However, the story is not over. In June 2022, Massachusetts's highest court ruled that Lanier had the right to sue Harvard for the "emotional distress" regarding "her request for information and acknowledgement"; still, the court denied Lanier the right to possession of the images themselves as Lanier herself was claiming descendancy of Renty and Delia—not of the photographer or the originating commissioner of the photograph.[19] Lanier's team strived to create a causal relationship, aiming to liken the images of Renty and Delia to sex trafficking or revenge porn.[20] Author and journalist Ta-Nehisi Coates described them as "hostage photograph[s]," emphasizing the

terroristic nature of how they were produced.[21] In particular, their digital virality does seem to indicate the public's discomfort with the nudity of the figures; some of the coverage, as it reproduces the image, even goes so far as to blur out Delia's breasts, as if this restores to her personhood some sense of dignity. Lanier has acutely reflected, "[Renty] is my ancestor [, not your] medium of exchange."[22]

Her description of Renty as being actioned as a "medium of exchange" speaks to the complexities of the ways in which the Black body, flattened and disembodied in its representation, digitally or otherwise, is transformed into an empty vessel, a container into which the affect of its bearers—in this case Agassiz, Harvard, and the American legal system—is poured and sustained. The Black meme as a souvenir rises again here. Poet and scholar Susan Stewart observes about what a souvenir can do, and how it labors:

> But whether the souvenir is a material sample or not, it will exist as a sample of the now-distanced experience, an experience which the object can only evoke and resonate to, and can never entirely recoup ... If the function of the souvenir proper is to create a continuous and personal narrative of the past, the function of such souvenirs of death is to disrupt that continuity. Souvenirs of the mortal body are not so much a nostalgic celebration of the past as they are an erasure of the significance of history.[23]

As such a souvenir, Renty and Delia are forever trapped in the architecture of their photographic frame, now transformed into an infinitely scrolling browser tab. Fetishized within an institutional archive, their captured images are simultaneously rendered silent and stripped of agency. They are untouchable in so many ways and, as a result, denied the possibilities of freedom. Hortense Spillers reflects on touch as a vehicle of emancipation:

Touch may be the first measure of what it means not to be enchained anymore. When I can declare my body as my own space and when you have to gain permission from me implicitly to put your hands on me, I think it makes a difference.[24]

Lanier's experience of not being able to put her hands on the images continues the legacy of the forced family separation as enacted by the machine of enslavement itself. Determined as property within their lifetimes, have Renty and Delia become what Dr. Nicole Fleetword terms "dead icon[s] on trial," to some degree blamed for being imaged in the first place?[25] The judge's ruling denying Lanier her right to bring them home can also be seen as a form of silencing. Such circumstances demand we heed Tina M. Campt's call to action: for us to "listen" to them and answer their calls from captivity.[26] It also forces us to consider further our relationship to questions of property and ownership. Jean Baudrillard reminds us of the inherent troubles enfolded in our instinct to keep, hold, and collect, commenting on the ways the economic, cultural, and social obsession with *ownership* makes the pursuit of capital hum with emotional frequencies: "Our everyday objects are in fact objects of a passion—the passion for private property."[27] What he calls a "serial game" is therefore, as art and cultural historian Sarah Elizabeth Lewis describes it, "an attempt to turn photographs into regularized data for colonial and imperial projects."[28]

This exercise of "collective ownership," made possible by Harvard placing Renty and Delia's images into the public domain, echoes the model of "open source" that doubles down as a tactic of dispossession. Such systems of free distribution of Renty's and Delia's respective Blackness appears to displace the institution's responsibility to its control over them, distributing and refracting this responsibility across innumerable points. These actions make it increasingly unlikely that the images will ever find their way back to Lanier within a single channel.

Rather than return to family and home, they now remain networked by the internet and the drive of its visual algorithm.

Reflecting on the act of image-making, Black American abolitionist Frederick Douglass noted: "Byron [the poet] says a man always looks dead when his Biography is written. The same is even more true when his picture is taken."[29] From this vantage point, we can wonder, then, whether the photographic capture of Renty and Delia as father and daughter intends, in its attempt at dehumanization of both individuals, to render them both as *dead property*. If this is the case, the circulation of their images without their consent, as an extension to this "death performance," is tantamount to the transmission of their digital remains. When items such as these photographs, captured and held without consent, travel from the physical archive to the internet, is this the equivalent of a data breach, a violation of Renty's and Delia's corporeal and sexual dignity and autonomy? And is the continued circulation of these images by the public a form of piracy?

In 2014 Massachusetts passed a "right of publicity" law, a genre of postmortem privacy that by its legal definition "allow[s] the posthumous transfer of a person's identity to their heirs or to the firms that represent them," thereby "bar[ring] companies from using their identities to sell products."[30] To view Lanier's case through the lens of postmortem privacy suggests initially the opportunity for recourse within US law, implying that perhaps it could be viable to have Lanier as an heir of Renty and Delia hold Harvard Corporation—touted as the oldest corporation in the Western Hemisphere—accountable. This 2014 "right to publicity" law, however, was deemed as inadmissible and therefore could not be applied. Presently, the "right to be forgotten"—which empowers individuals to request to be delisted from online search results such as Google—still does not extend outside of the European Union. Therefore, the Lanier family and their legal representation could not explore this as a viable channel of recourse. The subsequent failure

of the Massachusetts court to see the validity in the argument that Zealy's images of Renty and Delia were being held hostage by Harvard, and later the internet as a whole, seems to bypass the capacity of the 2014 law entirely. Unlike others protected under this umbrella, Lanier and her family lacked any postmortem right to privacy; as such, Renty and Delia remain digitally bound, captured and traded at will. Here we witness in real time data trauma, digital weathering, and digital John Henryism—as explored earlier in this text—in a flywheel, assuming new shapes and effects.

Andrew Gilden, a scholar of intellectual property and internet law, explains:

> A person's legacy is increasingly bound up in the continued circulation of IP-protected subject matter, and the legal ground rules for copying such subject matter implicates far more than profit streams for rights holders. They implicate questions of mourning, family privacy, and the ongoing emotional bonds between the living and the deceased ... IP laws are often used by successor rights holders not just for financial reward but also to ensure dignified representations of the deceased and respect for the family's often painful loss.[31]

No such privilege has been given to Renty and Delia. Gilden notes that these tensions are further complicated by the fact that digital platforms have created opportunities for the dead to be resurrected by the public, often without the permission of the individual or their kin.[32] In 2021, the Israeli online genealogy company MyHeritage launched a new feature called Deep Nostalgia™, which allows users to animate faces of their kin. Animations of Renty surfaced via this application, using the artificial-intelligence software of Deep Nostalgia™ to bring Renty back to life and into motion.[33] Similar resurrections were made at the time of Harriet Tubman and Frederick Douglass, prompting debate across cyberspace, and especially on Black

Twitter, around the ethics of such "deep fake technologies." This tension between the "real" and the "deep fake" manifests directly Baudrillard's "successive phases of the image," shaping yet another uncanny valley of Blackness transmuted into memetic diversion.[34] Still, in its movement via social media, Renty's reanimation via Deep Nostalgia™ intersected with and triggered the memorialization of many other Black figures who have entered into viral circulation in life, and death, alchemized further into dead icons made cyclically undead via the animating elixir of AI viral celebrity.

Here, one wonders: If Lanier's proposition that Renty and Delia are still laboring for Harvard—an afterlife of their enslavement, and a poor image of their resolve, resilience, and refusal—what would a labor strike against their distributed Blackness in this cyberspace look like?

11

MEME AFTERLIVES: LAVISH REYNOLDS IN BROADCAST (AND, ANYWAY, ARREST THE COPS THAT KILLED BREONNA TAYLOR)

"Now down [with the lights] a bit while it settles between them and keep it down while he watches her, just watches her, then fade him to black and leave her in the shadow while she looks for the feelings that lit up the room."
—Kathleen Collins, "Interiors"[1]

On July 6, 2016, Diamond Reynolds witnessed the murder of her fiancé, Philando Castile, a thirty-two-year-old high school cafeteria worker, at the hands of the Minneapolis police in Minnesota. Reynolds had finished work and picked up her four-year-old daughter from school while her partner Castile waited in the car. As they were driving home to have dinner, Officer Jeronimo Yanez pulled Castile over for a broken taillight. Only forty seconds passed before he shot Castile.

In the recordings captured by police and security cameras, Reynolds's voice rings out: "You just killed my boyfriend."[2] In the video, Reynolds's daughter watches from the back seat. Yanez shouts to another officer: "Get the baby girl out of here."[3] Reynolds, who has begun to stream the incident on Facebook Live with Castile bleeding to death in the seat next to her, is instructed by Yanez to step out of her car and get on the ground, face down. The police throw her phone. Reynolds, streaming under her online handle of "Lavish," steadily narrates: "They threw my phone, Facebook."[4]

There is a moment in the recording that continues to stream after Reynolds's phone drops to the ground where we can see the sky, bright blue with a single cut of a utility pole wire running across one corner. This split second reveals the "eye" of Reynolds's mobile device, the technology of her

phone performing as prosthesis, giving her and the viewers on Facebook Live "sight" of a blue sky, even though Reynolds's own eyes were likely seeing the asphalt beneath her. As Reynolds sits handcuffed in the back seat of the cop car, her daughter consoles her: "It's OK Mommy ... It's OK I'm right here with you ... I could keep you safe."[5]

The Facebook Live video was removed temporarily from the social network after being viewed 1 million times; the company claimed this was a technical error.[6] Within the hour, Facebook reinstated the ten-minute video with a "Warning—Graphic Video" message. As of the Thursday evening after the murder, Reynolds's video had generated more than 4.2 million views.[7] Reynolds told reporters, "I wanted to put it on Facebook and go viral so the people could see [and] determine who was right and who was wrong ... They took my lifeline ... [Philando] was my best friend."[8]

Reynolds's words, spoken sixty years after Mamie Till-Mobley's on the murder of her son, echo and are haunted by them: "Let the people see what they did to my boy."[9] Today, the video remains archived on YouTube on an account run by Ramsey County.[10] Despite the years that have passed, its views and shares keep climbing. Journalists reported Reynolds explaining,

> I didn't do it for pity. I didn't do it for fame. I did it so that the world knows these police are not here to protect and serve us. They are here to assassinate us. They are here to kill us because we are [B]lack.[11]

Such protestation is shattering. It speaks to the perception of Black death as an agent for celebrity: that to be recognized—if not necessarily to be *seen*—a Black person must be in proximity to the dead, or dead themselves. This hurts.

Take another example: in March 2020, Breonna Taylor, a Black medical worker, was shot and killed in a no-knock police

raid on her apartment in Louisville, Kentucky.[12] Twenty-two shots were fired; six of those shots struck Taylor, who died at the scene. Strikingly, the website knowyourmeme.com includes "Death of Breonna Taylor" in its listings, referring in its description to a Reddit post from May 14, 2020, that reads:

> On March 13, 2020, these three fuckers conducted a no-knock raid on Breonna Taylor's apartment. 22 shots were fired with some bullets going into other apartments. 6 of those bullets struck Ms. Taylor and ended her short life. THEY WERE AT THE WRONG APARTMENT.

That post, and the one that followed on May 29 from a Redditor who published the audio of the call Taylor's boyfriend made to 911, received thousands of points, upvoted at 94 and 95 percent respectively, a showing of the immense engagement metrics for this material when accessed by the public online.[13]

The police officers who raided Taylor's home initially claimed they were not using body cameras.[14] There was no broadcast to social media live-streamed by Taylor in the moment. Therefore, the public's witness, voyeurism, and spectatorship were at first obfuscated by the lack of "live" digital capture. In an effort to put together the pieces, the *New York Times* created a 3D digital recreation, empowering online audiences to watch and replay the timeline of that fateful evening.[15] While Taylor's family actively filed suit claiming the existence of the body camera footage in an effort to bring the fuller narrative of what took place to light and Taylor to justice, this lack of early memetic evidence was no barrier to the amplification of Breonna Taylor fandom, fetish, and visual commodification as it proliferated online internationally. Across the spring and summer of 2020, we watched waves of non-Black friends and colleagues, along with superstars we followed, shockingly posting clickbait images of "sideboob" and other references

unrelated entirely to Taylor alongside notes on Black Lives Matter.[16] Emblematic among these, Harry Potter star Emma Watson's June 2 Instagram post with the hashtag #SayHerName generated over 1.4 million likes in under twenty-four hours.[17]

The decorative donning of hashtags such as #SayHerName and #JusticeBreonnaTaylor in this early 2020 moment revealed yet again the relationship between Black death and visibility.[18] It made it clear that Black death, in its transmission, maximizes and makes hypervisible everyday Blackness that might otherwise be rendered invisible. It also catalyzes and advances the star power of those who apply it strategically. Indeed, the GoFundMe set up for Taylor's family raised over $6.5 million, and, in a first, Oprah Winfrey placed Taylor on the cover of *O, The Oprah Magazine* instead of the usual image of Winfrey herself.[19] What tennis champion Arthur Ashe in 1992 called "the totem pole of visibility" creates a codependent index of fame that binds Black viral trauma to the key performance indicators, or "KPIs," of excellence in contemporary media.[20] Ashe's "totem pole" signals an award for a model of Blackness that has been hewn to the sensation of injury, predicating visibility on an adoption of the age-old media adage "If it bleeds, it leads."[21] Thus, the staging (and restaging) of pain, and its application within digital culture as a garnish to Blackness, has prompted a rise and acceleration of the Black meme.

In August of 2020, I sent into the internet ether a series of tweets concerning the killing of Breonna Taylor and its digital digestion. Revisiting them now, in sequential order, they read:

The aestheticization of #BreonnaTaylor is unacceptable. It is not radical to make her image decorative. There is a complex art/history re: decorative concealing violence. Are beautiful images dignity—or justice? Is her family being compensated for the use of her image?

150

I honestly think we get confused when we see these images because we feel some sense of kinship with them—it is *so rare* to see quotidian everyday representation of ppl ESP a Black / femme "ordinary" with such visibility that we laud the presence + production of these images

We get confused + disoriented + feel pacified (bc that's what the decorative does!) but what is the message we send when we accept these images as "justice," in lieu of recognising them as overdue acknowledgement of dignity we are due not in our death, but in our ordinary life?

Demand more! We deserve more than a dignity campaign of the decorative![22]

The tweets themselves—a tender mourning and intimate expression of bewilderment in the face of the disturbing nature of what was witnessed on- and offline—went viral. While at the time it stunned me, given the pandemic isolation of the moment as many sheltered in place, the virality of these missives should not in any way have come as a surprise. They were part of a larger memetic circulation: a Google search for "Breonna Taylor decoration" surfaces results such as magazine covers, products sold on Etsy, Pinterest boards, wallpaper, and yard signs sold on Amazon for just $17.99—and that is just the start.

It is a difficult question to pose, but it must be asked: Is Taylor's afterlife one that lives on as an ornamentalized totem? Furthermore, is this yet another system of erasure, compounded by repetition? Culture writer Zeba Blay, in a July 2, 2020, *Huffington Post* article, identified where it hurt the most:

Turning Breonna Taylor into a meme, then, risks turning the conversation around what justice looks like for her into a temporary fad ... as "Arrest the cops who killed Breonna Taylor"

gets repeated over and over again, it becomes an abstraction, it begins to lose meaning.[23]

We wonder, then: *Is Blackness itself a decorative art?* The scholarship of art historian and curator Adrienne L. Childs illuminates these inquiries by reaching back in time, providing us with another anchor. In her study of eighteenth-century representations in European art, Childs unpacks what she terms as "ornamental Blackness":

> The vogue for representing the African body in decorative arts served to disseminate tropes of [B]lackness throughout spaces of wealth and refinement in rococo Europe ... the [B]lack servant in European art that had become a ubiquitous symbol of exoticism and luxury since the Italian Renaissance.[24]

It remains so today. Artist Lorraine O'Grady's essay "Olympia's Maid" brings to the fore the Black servant Laure in Édouard Manet's iconic 1863 painting *Olympia*, who is featured, troublingly, as a decorative prop. Grady writes: "Olympia's maid, like all the other 'peripheral Negroes' is a robot conveniently made to disappear into the background drapery."[25]

These Black femme figures of Laure and Taylor unify across time, mutually at risk of becoming fashionable motifs that function mechanically as signifying vessels. Both are failed by the culture that consumes them yet does not do the work to truly love them. Being part of the circulation of visual material has made each famous, but despite their hypervisibility, they fall short of being truly recognized in their humanity. Again, the relationship between icon and symbol surges: How can we honor Taylor without rendering her invisible via her hypervisibility? And what can reparations look like to repay the debt to the Black meme?

Professor K. J. Greene, a scholar of entertainment and intellectual property law, calls for some beginnings of these

reparations through what he terms revised "copynorms," an atonement for the cultural appropriation and creative theft of Black artists.[26] Greene flags contract and intellectual property law as foundational issues within a discourse of the transmission of Black material, writing, "No one wants their property taken from them and distributed without their permission ... For many generations, [B]lack artists as a class were denied the fruits of intellectual property protection—credit, copyright royalties and fair compensation."[27] Indeed, the current systems are reflective of deeply rooted historical frameworks of racial subordination, structural inequality, and asymmetric bargaining relations.

Greene underscores the issue of class as essential to an understanding of how these inequities have been compounded over time, with the content of cultural production often stemming from Black people's survival under the conditions of generations of disinherited wealth. As a consequence, the tradition of Blackness is transmitted somatically—what is embodied, worn and styled, how one moves, speech acts and vernacular utterances, sonic and haptic practices—rather than transferred via the inheritance, or carrying, of valued physical objects as property. Blackness as it intersects with modernity, therefore, has always been the commodity to transmit, and the asset to maximize via viral broadcast.

Legal scholars Anjali Vats and Diedré Keller's 2018 article "Critical Race IP" expands on Greene's proposal, observing, "With the radical changes brought by Betamax, VHS, the Internet, and Napster between the 1970s and 1990s, big content owners found themselves in deeply unfamiliar and rapidly shifting territory that impacted their core business models."[28] While "big content owners" were initially unfamiliar with how to succeed with the accelerated technologies as they kept advancing, what we can frame here as "little content owners" (for the sake of shaping an opposing force in dialogue with Vats and Keller) have been, and are increasingly today, tasked

with strategizing towards virality. Thus, the most viable asset that one has in one's possession is Blackness as a "core business model" itself.

For those not born with it, this has a twist: if one is not Black, this same culture that renders Black people invisible via their hypervisibility sends the paradoxical message that if one wants to be seen, one had better "Black up" real quick. For many non-Black "content creators" now, what White American novelist Norman Mailer augured in the title of his erythrogenic 1957 essay *White Negro* has somehow become a calling and vocation.[29]

With all these copies of the copies in the minstrelsy of Black digital memesis, it becomes difficult, then, to attempt to see, feel for, or engage directly the original. As Greene reminds us, authorship "is the foundation of copyright, and authorship, like race and gender, is socially constructed."[30] This is why we have to keep fighting for all Black womxn, alongside continuing to fight for Taylor and the authorship of her personhood as an individual with agency.

OUTRO IN REMIX:
LYRIC FOR THE BLACK MEME

"When you go around the world, you realize that [Blackness]
has been this revolutionizing force on the rest of the world, and
it's how people understand their own liberation ... this is the
language of liberation around the world, everywhere you go."

—Danzy Senna[1]

If Blackness has been transformed into, as novelist Danzy
Senna observes, a global skin and "language of liberation,"
we risk its transformation into a unifying locality or meeting
place. With this in mind, it is essential that the performance of
Blackness as a digital skin is not neutralized within this shared
"language" as the status quo. Though the viral copies of copies
seem to keep accelerating, the strategies of dissemination need
to be renegotiated and regulated: the old formulas that have
long been broken will not work for this internet.

French poet Charles Baudelaire described the flâneur as

like a roving soul in search of a body ... enter[ing] another
person whenever he wishes. For him alone, all is open; if certain
places seem closed to him, it is because in his view they are not
worth inspecting.[2]

The imagination of Baudelaire's wanderer—an invention that
arises historically out of a modernized industrial worldview
intended to center Whiteness and its freedom of movement

first and foremost—is emancipated *specifically because* it is assumed to be "neutral": *unraced, unclassed, ungendered, unafraid,* and down to take whatever form that best suits the supremacy of this imagined fetishized body. However, none of this is neutral territory.

Extended to the present, Baudelaire's troubled figure of the flâneur serves as a call to action for fellow wanderers of cyberspace: non-Black "roving souls in search of a body" online, haunting and inhabiting Blackness as a decorative corporeality. This cannot continue. Similarly in need of expiration is the incessant pathologizing of Black people who voice their desire for a mutuality in equitable economies of recognition and compensation for their creative work, who are so often accused of what amounts to digital drapetomania—those seeking fugitivity from the algorithms and audiences that dictate their subalterity as a requirement of their visibility through our screens are consistently narrated as ungrateful, undeserving, or inconvenient, rather than rightfully empowered, self-determined, and informed. An active exorcism of all the bodies the Black meme carries as a fantasy and projection by a culture that fails to adequately care for, love, and invest in the sustainable life of Black people, this now is a project of digital decolonization to carry forward. We need an epistemological and somatic reinhabitation and reanimation of all the bodies that have been consumed, extracted, commodified, assimilated, and appropriated without recourse or consent. The Black meme must strike, rebel, refuse, mutiny.

Therefore, let us demand that Blackness—and its transmission—be recognized as something more than an aesthetic event, refusing an ornamental Black becoming within the diaspora of the digital. As we have seen, a careful study of the prehistory of the internet clarifies our understanding of the birth of a digital nation, and specifically the ways in which today's drivers on this information superhighway may be complicit with a heritage of cultural failures that has used the Black meme in

imitation, without considering its origins. *Give Black memes their royalties.*

The demand for royalties becomes all the more pressing as the rise of AI prompts new questions about what it means to inhabit Blackness. We see this in examples such as the creation of the "world's first digital supermodel," Shudu, featured on the Instagram account @shudu.gram, who has over 200K followers. Known as a "virtual influencer," Shudu—the digitally Black 2017 creation of fashion photographer Cameron-James Wilson, a White British man—does not exist in the physical world. The AI model, surprisingly enough, is both voiced and has her story actively shaped and narrated by Black writer Ama Badu. Badu writes:

> I saw [Shudu] as art, as Cameron's way of expressing another form of his creativity. I loved that she was so dark, that her hair was so short. I loved the brands she collaborated with too. The fashion industry is shifting. The demand for inclusivity and diversity is currently changing the way we perceive beauty. Shudu is part of this change.[3]

In November 2022, the artificial intelligence chatbot ChatGPT was released by the American AI research lab OpenAI. As it went viral, the chatbot came under amplified scrutiny as users discovered and exploited loopholes in its programming that presented complex race and gender biases.[4] In 2023, the viral sensation of "Heart on My Sleeve"—a song that used AI versions of the voices of hip-hop singers Drake and the Weeknd—prompted new inquiries into what shape digital blackface can take. First appearing on TikTok as published by an anonymous producer under the account handle of @ghost writer977, the song generated over 9 million views within days of going live. The conversation, as it extends itself in a myriad of directions, is not solely about the "skin" of the digital but also about its sonic nature, and how this might be applied as a

memetic strategy in securing the popularity of digital content. If physical property, as we have established it here, is predicated on a model that is inherently extractive in its historic and legal frameworks, then a structure of ownership, as it entangles itself with the digital, requires a new imagination entirely. To adequately address the economy of unpaid labor triggered by these transmissions on loop necessitates a breaking and remaking of digitality, one predicated on new definitions of authorship. The internet now is the largest institution of visual culture on earth. If this is the case, our very definitions of provenance must be better stipulated and restructured to encompass the study of Black movement and sound as they travel digitally. It is an exciting if not staggeringly complex next frontier.

In her prescient 1979 poem "Computer," Gwendolyn Brooks writes:

> I conduct a computer
> A computer does not conduct me.[5]

As a conductor, what are you transmitting? And are you listening?

Here is the chant: *Reparations now! Free the Black meme!*

BELOVEDS

Alexandra Bynoe-Kasden
Allison Weisberg
American Artist
Dr. André L. Brock Jr.
Andreas Laszlo Konrath
Aria Dean
Brittni Chicuata
Christina Sharpe
chukwumaa
Courtney Willis Blair
Daonne Huff
E. Jane
Elizabeth Karp-Evans
Ernest Russell (DIGITALMAN)
Evans Richardson IV
Fred Moten
Garrett Bradley
Gi (Ginny) Huo
Kaitlin Kylie Pomerantz
Dr. Kamala Joie Mottl, PhD
Lena Imamura
Leo Hollis
Lorraine O'Grady
Madeleine Hunt-Ehrlich
manuel arturo abreu
MHYSA
Naudline Pierre
Dr. Nicole Fleetwood
Nora Clancy
Rashida Bumbray
Roselee Goldberg
Salome Asega
Sami Hopkins

BELOVEDS

Sarah Elizabeth Lewis
Sarah Jones
Simone Leigh
Simone White
Thelma Golden

The Kitchen
The Studio Museum in Harlem

BROADCAST VIA

Creative Capital Award 2021
home school, Portland, OR
Surf Point Foundation Residency 2022

*The lecture and video piece "Black Meme" was first
presented online as part of Discrit programming on
June 27, 2020, at Atlanta Contemporary.*

NOTES

Overture

1 Fred Moten, "Resistance of the Object: Aunt Hester's Scream," in *In the Break: The Aesthetics of the Black Radical Tradition*, Minneapolis: University of Minnesota Press, 2003, p. 1.

2 Also referred to as *Lime Kiln Club Field Day* or *Bert Williams: Lime Kiln Field Day*.

3 Benjamin Sutton, "MoMA Uncovers First Feature Film with a Black Cast," *Artnet News*, September 22, 2014, news.artnet.com.

4 Alex Arbuckle, "The Black Comedian Who Quietly Shattered Racial Barriers," *Mashable*, February 25, 2016, mashable.com.

5 *Lime Kiln Field Day*, directed by T. Hayes Hunter and Edwin Middleton (1914; MoMA, 2014, moma.org); Garrett Bradley, *America*, MoMA, November 21, 2020 – March 21, 2021.

6 Garrett Bradley, Thelma Golden, and Legacy Russell, "Re-Imaging America," MoMA, November 19, 2020, moma.org.

7 Ashley Clark, "Back to Black: The 101-Year Making of the Oldest Black American-Starring Feature," *Sight and Sound*, May 26, 2015, bfi.org.

8 Rebecca Bengal, "How Garrett Bradley's Films Reset Our Personal Algorithms," *WSJ Magazine*, October 1, 2020, wsj.com.

9 Bradley, Golden, and Russell, "Re-Imaging America."

10 Hannah Arendt, "Lying Politics: Reflections on the Pentagon Papers," *New York Review of Books*, November 18, 1971.

11 Mark E. Benbow, "Birth of a Quotation: Woodrow Wilson and 'Like Writing History with Lightning,'" *Journal of the Gilded Age and Progressive Era* 47, no. 1 (Autumn 2007), pp. 509–33.

12 Paul McEwan, "Racist Film: Teaching 'The Birth of a Nation,'" *Cinema Journal* 47, no. 1 (Autumn 2007), pp. 98–101.

13 Richard Brody, "The Worst Thing about 'Birth of a Nation' Is How Good It Is," *New Yorker*, February 1, 2013, newyorker.com.

14 Steven Jay Schneider, ed., *1001 Movies You Must See Before You Die*, 7th ed., Hauppauge, New York: Barron's Educational Series, 2014, p. 24.

15 Richard Corliss, "D. W. Griffith's *The Birth of a Nation* 100 Years Later: Still Great, Still Shameful," *Time*, March 3, 2015, time.com.

16 Rachel E. Greenspan, "How the Name 'Karen' Became a Stand-In for Problematic White Women and a Hugely Popular Meme," *Insider*, October 26, 2020, insider.com.

17 Jeff Arnold, "Charges against 'Central Park Karen' Amy Cooper Dismissed: DA," *Patch*, February 16, 2021, patch.com.

18 Wanna (@wannasworld), "Can we start a thread and post all of the white girls cosplaying as black women on Instagram?," Twitter, November 6, 2018, twitter.com; Wanna Thompson, "How White Women on Instagram Are Profiting off Black Women," *Paper*, November 14, 2018, papermag.com; Amira Rasool, "Some White Influencers Are Being Accused of 'Blackfishing,' or Using Makeup to Appear Black," *Teen Vogue*, November 16, 2018, teenvogue.com.

19 Tanya Chen, "A White Teen Is Denying She Is 'Posing' as a Black Woman on Instagram after Followers Said They Felt Duped," *Buzzfeed News*, November 13, 2018, buzzfeednews.com.

20 DAWN (@DawnRichard), "Behahahahaha ... Filter is the new bleach. I mean it's cheaper tho I guess," Twitter, March 19, 2013, twitter.com.

21 doreen st. félix (@dstfelix), "everybody wanna be a black woman but nobody wanna be a black woman," Twitter, December 11, 2014, twitter.com.

22 Lauren Michele Jackson, "We Need to Talk about Digital Blackface in Reaction GIFs," *Teen Vogue*, August 2, 2017, teenvogue.com.

23 Laur M. Jackson, "Memes and Misogynoir," *Awl*, August 28, 2014, theawl.com.

24 Harmony Holiday, "The Black Catatonic Scream," *Triple Canopy*, August 20, 2020, canopycanopycanopy.com.

25 Ibid.

26 Dead Prez, *Let's Get Free*, Loud Records, 2000, compact disc.

27 Meg Onli, ed., *Speech/Acts*, New York: Institute of Contemporary Art, 2017, p. 22.

28 American Artist, "Bobby Shmurda: Viral and Invisible," *New Criticals*, May 12, 2016, newcriticals.com.

29 Aldon Nielsen, *Black Chant: Languages of African American Postmodernism*, New York: Cambridge University Press, 1997, p. 168.

30 Molly Wood, "How the History of Blackness on the Internet Was Erased," *Marketplace*, February 10, 2021, marketplace.org.

31 Celebrating the contributions and work of André Brock Jr., author of *Distributed Blackness: African American Cybercultures* (2020).

32 The exhibition, organized by Lumi Tan, took place at New York City's contemporary art and performance institution The Kitchen. Terence Trouillot, "Sondra Perry's Resident Evil," *Bomb*, December 8, 2016, bombmagazine.org.

33 "Voyages: The Transatlantic Slave Trade Database," National Endowment for the Humanities, January 21, 2011, neh.gov; Adam Satariano, "How the Internet Travels across Oceans," *New York Times*, March 10, 2019, nytimes.com.
34 Tabita Rezaire, *Exotic Trade*, digital catalogue, tabitarezaire.com.
35 Neema Githere, interview by Ethel Tawe, *BOMB*, April 19, 2022, bombmagazine.org.
36 Yaa Addae, "Data Healing: Digital Doulas Take Restorative Justice to Cyberspace," *Bitch Media*, June 15, 2020, bitchmedia.org.
37 A. T. Geonimous, "The Weathering Hypothesis and the Health of African-American Women and Infants: Evidence and Speculations," *Ethnicity and Disease* 2, no. 3 (Summer 1992), pp. 207–21; Gene Demby, "Making the Case That Discrimination Is Bad for Your Health," NPR, January 14, 2018, npr.org.
38 Ibid.
39 A networked expansion of the medical phenomenon of "John Henryism," a term first coined in 1983 by American epidemiologist Sherman James. Richard Fisher, "'John Henryism': The Hidden Impact of Race Inequality," BBC, August 23, 2020, bbc.com.
40 Hito Steyerl, "Too Much World: Is the Internet Dead?," *e-flux Journal*, November 2013, e-flux.com.
41 Wilfred Chan, "$7,000 a Day for Five Catchphrases: The TikTokers Pretending to Be 'Non-playable Characters,'" *Guardian*, July 19, 2023; Autumn Alston, "Beating Racial Algorithms to Even the Odds of TikTok Fame," *Mary Sue*, September 7, 2023, themarysue.com.
42 Hito Steyerl, "In Defense of the Poor Image," *e-flux Journal*, November 2009, e-flux.com.
43 Aria Dean, "Poor Meme, Rich Meme," *Real Life*, July 25, 2016, reallifemag.com.

1. STRANGE FRUIT, GONE VIRAL

1 Glenn Ligon, "Notes on a Performance by Kellie Jones," in *On Value*, ed. Ralph Lemon, New York: Triple Canopy, 2015, p. 75.
2 42 Cong. Rec. S6132 (May 12, 1908).
3 "Reconstruction in America: Racial Violence after the Civil War, 1865–1876," Equal Justice Initiative, 2020, eji.org.
4 "Lynching in America: Confronting the Legacy of Racial Terror," Equal Justice Initiative, 2017, lynchinginamerica.eji.org.
5 Meserette Kentake, "James Cameron: The Only Known Survivor of a Lynching," *Kentake Page*, February 25, 2016, kentakepage.com.
6 Syreeta Mcfadden, "What Do You Do after Surviving Your Own Lynching?," *Buzzfeed News*, June 23, 2016, buzzfeednews.com.
7 "The Lynching of Thomas Shipp and Abram Smith, 1930," *Rare*

Historical Photos (blog), updated November 23, 2021, rarehistorical
photos.com. Beitler's photograph of the lynching of Shipp and
Thomas "is believed to have inspired Abel Meeropol's 1937 poem
'Bitter Fruit.' Two years later that poem became the lyrics of
Meeropol's 'Strange Fruit,' the dirge Billie Holiday made famous":
David Bradley, "Anatomy of a Murder," *Nation*, May 24, 2006,
thenation.com.

8 Mcfadden, "Surviving Your Own Lynching."
9 The standard editorial rights provide usage an "unlimited number
 of times for up to 15 years, worldwide, with uncapped indemnifica-
 tion"; Hulton Archive, "Public Lynching," Getty Images, gettyimages
 .com.
10 Mcfadden, "Surviving Your Own Lynching."
11 It is worth noting that artist and writer James Bridle coined this
 term but that Cameron's experience predates the rise of the "new
 aesthetic" as a discourse.
12 Henry Jenkins, *Convergence Culture: Where Old and New Media
 Collide*, New York: New York University Press, 2008, p. 2.
13 W. E. B. Du Bois, "Strivings of the Negro People," *Atlantic*, August
 1897, theatlantic.com.
14 Rooting in the original meaning of the term, as in "relating to finger
 or fingers," e.g., *of one's hand*.
15 André Brock Jr., *Distributed Blackness: African American Cyber-
 cultures*, New York: New York University Press, 2020.
16 Interview with Hayden White, in *Encounters: Philosophy of History
 after Postmodernism*, ed. Ewa Domanska, Charlottesville: University
 of Virginia Press, 1998, p. 16.
17 Patricia R. Zimmerman, "Public Domains: Engaging Iraq through
 Experimental Digitalities," *Framework: The Journal of Cinema and
 Media* 48, no. 2 (Fall 2007), p. 69.
18 Margaret Rouse, "Graphics Interchange Format," *Techopedia*,
 November 9, 2017, techopedia.com; Margaret Rouse, "What Does
 Animated GIF Mean?," *Techopedia*, August 25, 2016, techopedia
 .com.
19 Sianne Ngai, *Ugly Feelings*, Cambridge, MA: Harvard University
 Press, 2007, pp. 91–2.
20 Amy Louise Wood, "Lynching Photography and the Visual Repro-
 duction of White Supremacy," *American Nineteenth Century History*
 6, no. 3 (2005).
21 "Postcard - Rare March 3, 1910 Lynching Scene in Dallas TX," ebay
 .com. No longer listed; accessed summer 2020.
22 Allen Brookes, "Victim of 120 Year Old Lynching Is Remembered
 in Dallas," *New York Times*, November 20, 2021, nytimes.com
23 "Biography," cindysherman.com.

24 In reference to the title of the incredible contribution *Enacting Others* (2011) by scholar Cherise Smith.

25 *White: Whiteness and Race in Contemporary Art*, International Center of Photography, December 10, 2004 – February 27, 2005; *Only Skin Deep: Changing Visions of the American Self*, International Center of Photography, December 12, 2003 – February 29, 2004.

26 E. Jane, "#CINDYGATE," October 25, 2015, e-janestudio.tumblr.com; Marina Garcia-Vasquez, "#CindyGate and the Lasting Stain of Cindy Sherman's Blackface Photos," *Vice*, October 30, 2015, vice.com; Priscilla Frank, "Cindy Sherman's Early Blackface Photos and the Art World's White Gaze," *HuffPost*, August 18, 2016, huffpost.com.

27 Tina M. Campt, *Listening to Images*, Durham, NC: Duke University Press, 2017, p. 11.

28 Hannah Giorgis, "When They See Us and the Persistent Logic of 'No Humans Involved,'" *Atlantic*, June 3, 2019, theatlantic.com.

29 Sylvia Wynter, "No Humans Involved," *Knowledge for the 21st Century* 1, no. 1 (Fall 1994).

30 Legacy Russell, "WYD: Glitching Cyborgian Négritude," lecture, Frank-Ratchye STUDIO for Creative Inquiry, Carnegie Mellon University, October 23, 2020.

31 Rudolf Baranik, "THE NIGGER DRAWINGS: A Note from New York," *Art Monthly (Archive: 1976–2005)*, no. 29 (September 1, 1979), pp. 27–8.

32 *Act 2: The Nigger Drawings*, Artists Space, 1979, p. 67.

33 "Black Emergency Cultural Coalition Records 1971–1984," New York Public Library Archives and Manuscripts, archives.nypl.org.

34 Jacqueline Trescott, "Minorities and the Visual Arts: Controversy before the Endowment," *Washington Post*, May 2, 1979, washingtonpost.com.

35 Grace Glueck, "'Racism' Protest Slated over Title of Art Show," *New York Times*, April 14, 1979, nytimes.com.

36 Ibid.

37 Trescott, "Minorities and the Visual Arts."

38 Glueck, "'Racism' Protest Slated."

39 *Act 2: The Nigger Drawings*, p. 69

40 Ibid., p. 74

41 Helene Winer, quoted in R. Goldstein, "Romance of Racism," *Village Voice*, April 2, 1979; Howardena Pindell, "Action against Racism in the Arts," *Howardena Pindell: What Remains to Be Seen*, Museum of Contemporary Art Chicago, 2018, pindell.mcachicago.org.

42 W. E. B. Du Bois, *Darkwater: Voices from within the Veil*, London: Verso, 2021 [1920], postscript.

43 See "Slide image of an untitled triptych in 'The Nigger Drawings,'" included here: Joseph Henry, "Sources of Harm: Notes on the Alternative Artworld," *Hyperallergic*, September 11, 2014, hyperallergic .com.

44 "DONALD: The Nigger Drawings," AbeBooks, abebooks.com.

2. EATING THE OTHER

1 Transcript of the trial for the murder of Emmett Till by J. W. Milam and Roy Bryant, Special Collections and Archives, Florida State University Libraries, Tallahassee, Florida, FSU: 390158.

2 Maureen Corrigan, "'Let the People See': It Took Courage to Keep Emmett Till's Memory Alive," WBUR, October 30, 2018, wbur.org.

3 William Bradford Huie, "The Shocking Story of Approved Killing in Mississippi," *Look*, January 24, 1956.

4 Shaila Dewan and Ariel Hart, "F.B.I. Discovers Trial Transcript in Emmett Till Case," *New York Times*, May 18, 2005, nytimes.com.

5 Transcript of the trial for the murder of Emmett Till.

6 Ibid.

7 Ibid.

8 Allson Miller, "The World-Class Photography of *Ebony* and *Jet* Is Priceless History. It's Still Up for Sale," *Perspectives on History*, July 9, 2019, historians.org.

9 "When One Mother Defied America: The Photo That Changed the Civil Rights Movement," *Time*, July 10, 2016, time.com.

10 Shaila Dewan, "How Photos Became Icon of Civil Rights Movement," *New York Times*, August 28, 2005, nytimes.com.

11 "When One Mother Defied America"; Corrigan, "Let the People See."

12 Manthia Diawara, "Black Spectatorship Problems of Identification and Resistance," *Screen*, vol. 29, no. 4 (Autumn 1988), pp. 66–8.

13 Dave Mann, *Till Boy's Funeral, Burr Oaks Cemetary [sic]*, September 6, 1955, courtesy of the Smithsonian Institution Libraries.

14 bell hooks, "The Oppositional Gaze," in *Black Looks: Race and Representation*, Boston: South End Press, 1992, p. 117.

15 Quoted from my Facebook post, as it appears in Julia Reinstein, "A White Artist's Painting of Emmett Till Has Sparked Protest (and a Hoax Apology Letter)," *Buzzfeed News*, March 28, 2017, buzzfeed .com.

16 Jared Sexton, "The Social Life of Social Death: On Afro-Pessimism and Black Optimism," *InTensions*, no. 5 (November 2011).

17 Lovia Gyarkye and Jo Livingstone, "The Case against Dana Schutz," *New Republic*, March 22, 2017, newrepublic.com.

18 Jo Rosenthal, "A Timeline of the Dana Schutz Emmett Till Painting Controversy," *i-D*, March 17, 2023, i-d.vice.com.

19 Christina Sharpe, quoted in Siddhartha Mitter, "'What Does It Mean to Be Black and Look at This?' A Scholar Reflects on the Dana Schutz Controversy," *Hyperallergic*, March 24, 2017, hyperallergic .com.

20 Corrigan, "Let the People See."

21 Dawn M. Turner, "Popular Culture's Embrace of Emmett Till," *Chicago Tribune*, September 9, 2015, chicagotribune.com; Rich Samuels, "The Murder and the Movement," WMAQ-TV, July 1985, available at richsamuels.com; Corrigan, "Let the People See."

22 Photography attributed to Blair Stapp, Composition by Eldridge Cleaver, Huey Newton seated in wicker chair, 1967. Lithograph on paper; Collection of Merrill C. Berman.

23 "Teyana Taylor—Still (Official Video)," YouTube video, posted by @teyanataylor, September 2, 2020.

24 Kwame Holmes, "Necrocapitalism, or, THE VALUE OF BLACK DEATH," *Bully Bloggers*, July 24, 2017, bullybloggers.wordpress .com.

25 Ibid.

26 "Gun that Killed Trayvon Martin 'Makes $250,000 for Zimmerman,'" BBC, May 22, 2016, bbc.com.

27 Travis M. Andres et al., "Going for $65 Million: George Zimmerman's Gun Is Up for Auction Again," *Washington Post*, May 13, 2016, washingtonpost.com.

28 Smithsonian (@smithsonian), "We have never expressed interest in collecting George Zimmerman's firearm, and have no plans to ever collect or display it in any museums," Twitter, May 12, 2016, twitter .com.

29 Dave Tell, "Bryant's Grocery and Meat Market," *Emmett Till Memory Project*, tillapp.emett-till.org.

30 "Ben Roy's Service Station," Beard + Riser Architects, beardriser .com.

31 Dave Tell, "Can a Gas Station Remember a Murder?," *Southern Cultures* 23, no. 3 (Fall 2017), southerncultures.org.

32 Dave Tell, "Bryant's Grocery and Meat Market."

33 Money Rd, Greenwood, MS 38930.

34 Fred Moten, "Resistance of the Object: Aunt Hester's Scream," in *In the Break: The Aesthetics of the Black Radical Tradition*, Minneapolis: University of Minnesota Press, 2003, p. 1.

35 Vincent Woodard, *The Delectable Negro*, New York: New York University Press, 2014, pp. 14, 19.

36 Ibid., p. 38

37 bell hooks, "Eating the Other: Desire and Resistance," in *Black*

Looks: Race and Representation, Boston: South End Press, 1992, pp. 21–39.

38 Boris Groys, "Religion in the Age of Digital Reproduction," *e-flux journal*, March 2009, e-flux.com.

39 Walter Benjamin, *The Work of Art in the Age of Mechanical Reproduction*, trans. J. A. Underwood, Harlow: Penguin Books, [1935] 2008.

40 Cherise Smith, *Enacting Others: Politics of Identity in Eleanor Antin, Nikki S. Lee, Adrian Piper, and Anna Deavere Smith*, Durham: Duke University Press, 2011, p. 16.

41 Elizabeth Alexander, "The Trayvon Generation," *New Yorker*, June 15, 2020, newyorker.com.

42 In reference to Ron Eglash et al., eds., *Appropriating Technology: Vernacular Science and Social Power*, Minneapolis: University of Minnesota, 2004.

43 Hortense J. Spillers, "Mama's Baby, Papa's Maybe: An American Grammar Book," *Diacritics* 17, no. 2 (Summer 1987), p. 75.

3. SELMA ON MY MIND

1 Pamela Sneed, "If the Capitol Rioters Had Been Black," Houston, TX: F, 2021.

2 Errin Whack, "Who Was Edmund Pettus?," *Smithsonian Magazine*, March 7, 2015, smithsonianmag.com.

3 James Doubek, "Reimagining the James Baldwin and William F. Buckley Debate," NPR, September 20, 2020, npr.org.

4 "The American Dream and the American Negro," *New York Times*, March 7, 1965, nytimes.com.

5 Robbie Brown, "45 Years Later, an Apology and 6 Months," *New York Times*, November 15, 2010, nytimes.com.

6 Ibid.

7 John Fleming, "The Death of Jimmie Lee Jackson," *Anniston Star*, March 6, 2005, annistonstar.com.

8 "Un(re)solved: Jimmie Lee Jackson," PBS, pbs.org.

9 For a compilation of footage, see "Selma Marches—March 7–25, 1965," YouTube video, posted by @nbcuarchives, March 2, 2015.

10 "Civil Rights Protesters Beaten in 'Bloody Sunday' Attack," *History*, March 4, 2020, history.com.

11 Katie McLaughlin, "5 Surprising Things that 1960s TV Changed," CNN, August 25, 2014, cnn.com.

12 "Drunkenness, Sex Orgies Blemished March—Dickinson," *Montgomery Advertiser*, March 31, 1965.

13 111 Cong. Rec. H8599–603 (1965).

14 "Drunkenness, Sex Orgies."

15 "Civil Rights: Mud in the House," *Time*, March 7, 1965, time.com.
16 Nancy Doyle Palmer, "Selma and Richard Valeriani: A Reporter's Story," *HuffPost*, January 5, 2015, huffpost.com.
17 "#Selma50: What the Media and Hollywood Got Wrong about 'Bloody Sunday,'" NBC News, March 8, 2015, nbcnews.com.
18 "Selma, Alabama: The Role of News Media in the Civil Rights Movement," PBS Learning Media, 2013, ny.pbslearningmedia.org.
19 "#Selma50."
20 Ibid.
21 Gene Roberts and Hank Klibanoff, *The Race Beat: The Press, the Civil Rights Struggle, and the Awakening of a Nation*, New York: Vintage, 2006, p. 388.
22 Ibid.
23 J. Mills Thornton, "Selma to Montgomery March," *Encyclopedia of Alabama*, March 14, 2007, encyclopediaofalabama.org.
24 "Voting Rights Act (1965)," National Archives, archives.gov.
25 Erin Blakemore, "How the U.S. Voting Rights Act Was Won—and Why It's Under Fire Today," *National Geographic*, August 6, 2020, nationalgeographic.com.
26 "#Selma50."
27 Kerry Alexandra, "'I Am a Vessel': #BlackLivesMatter Muse," BBC, July 11, 2016, bbc.com.
28 Ja'han Jones, "2 Years after Going Viral, Iesha Evans Reflects on Her Iconic Protest Photo," *HuffPost*, July 5, 2018, huffpost.com.
29 "The Role of News Media."
30 Hortense J. Spillers, quoted in Alexander G. Weheliye, *Habeas Viscus: Racializing Assemblages, Biopolitics, and Black Feminist Theories of the Human*, Durham, NC: Duke University Press, 2014, p. 39.

4. SPORTING THE BLACK COMPLAINT

1 Andrew Maraniss, "The Mexico City Olympics Protest and the Media," *Landscape*, October 15, 2018, landscape.com.
2 "The Olympics: Black Complaint," *Time*, October 25, 1968.
3 Norman, in solidarity with Smith and Carlos, wore a badge for the Olympic Project for Human Rights, an organization founded in protest against racial discrimination in sports.
4 Joseph M. Sheehan, "2 Black Power Advocates Ousted from Olympics," *New York Times*, October 19, 1968, nytimes.com.
5 Norman also wore this same button, but it was not reported by Reynolds in this broadcast. Maraniss, "Mexico City Olympics."
6 ABC Evening News, "Olympics / Black Power," 03:40, October 17, 1968, courtesy of Vanderbilt Television News Archive.

7 Adam Bradley, "The Timeless Appeal of Tommie Smith, Who Knew a Podium Could Be a Site of Protest," *New York Times*, August 6, 2021, nytimes.com.

8 A. Dimond, "Iconic Olympic Moments: The Black Power Salute," *Bleacher Report*, July 24, 2008, bleacherreport.com.

9 Carlos was quoted saying to the BBC: "I can't eat that and the kids on my block ... they can't eat publicity, they can't eat gold medals ... all we ask for is an equal chance to be a human being": *Not Just a Game: Power, Politics, and American Sports*, dir. Jeremy Earp, 2010: Media Education Foundation; DeNeen L. Brown, "'A Cry for Freedom': The Black Power Salute That Rocked the World 50 Years Ago," *Washington Post*, October 16, 2018, washingtonpost.com.

10 Ibid.

11 A reference to song widely popularized by Billie Holiday. The original poem, "Bitter Fruit," was written in 1936 by Jewish American high school teacher Abe Meeropol after seeing the viral image of the lynching of Thomas Shipp and Abram Smith. The poem was published in 1937 in the teachers union journal *New York Teacher*, and later in the Marxist journal *New Masses*. John Carlos and David Zirin, *The John Carlos Story: The Sports Moment That Changed the World*, Chicago: Haymarket Books, 2011, ch. 5, para. 38.

12 "John Carlos: 1968 Olympics Protest 'a Resounding Statement That Would Reach the Far Ends of the Earth,'" BBC, July 29, 2021, bbc .com.

13 Brown, "A Cry for Freedom."

14 Paul Vitello, "John Dominis, a Star Photographer for Life Magazine, Dies at 92," *New York Times*, December 31, 2013, nytimes.com.

15 Brown, "A Cry for Freedom."

16 Carlos and Zirin, *John Carlos Story*.

17 Analis Bailey, "On This Day Four Years Ago, Colin Kaepernick Began His Peaceful Protests during the National Anthem," *USA Today*, August 26, 2020, usatoday.com.

18 Tadd Haislop, "Colin Kaepernick Kneeling Timeline: How Protests during the National Anthem Started a Movement in the NFL," *Sporting News*, September 13, 2020, sportingnews.com.

19 Pat Graham and Eddie Pells, "'Where All People Who Are Oppressed Meet': U.S. Shot Putter Gestures atop Olympic Podium," CBC, August 1, 2021, cbc.ca.

20 Bradley, "Timeless Appeal of Tommie Smith."

21 "Television Pioneer Helped Develop Slow Motion Sports Replay Technology," *San Diego Union Tribune*, September 28, 2010, sandiego uniontribune.com; Mike Barnes, "ABC Sports' Robert Trachinger Dies," *Hollywood Reporter*, September 28, 2010, hollywoodreporter .com; Edith Noriega, "From Slow-Motion to Live TV: '68 Olympics

Impacted How We Watch Today," *Global Sport Matters*, October 29, 2018, globalsportmatters.com.
22 David Davis, "Olympic Athletes Who Took a Stand," *Smithsonian Magazine*, August 2008, smithsonianmag.com.
23 Tommie Smith and David Steele, *Silent Gesture: The Autobiography of Tommie Smith*, Philadelphia: Temple University Press, 2007, pp. 1–2.

5. VIRAL ZOMBIISM

1 "U.S. Census Bureau History: Public Broadcasting," United States Census Bureau, October 2015, census.gov.
2 Steven Beschloss, "Object of Interest: Remote Control," *New Yorker*, November 22, 2023, newyorker.com.
3 Everett Rogers, "Video Is Here to Stay," *Center for Media Literacy*, 1988, medialit.org.
4 Ibid.; Priya Ganapati, "June 4, 1977: VHS Comes to America," *Wired*, June 4, 2010, wired.com.
5 Felicity Barringer, "White-Black Disparity in Income Narrowed in '80s, Census Shows," *New York Times*, July 24, 1992, nytimes.com.
6 Cheryl I. Harris, "Whiteness as Property," *Harvard Law Review* 106, no. 8 (1993), pp. 1707–91
7 Ibid., p. 1729
8 Ibid., pp. 1731–2
9 Nancy Griffin, "The 'Thriller' Diaries," *Vanity Fair*, June 24, 2010, vanityfair.com.
10 Ibid.
11 Jackson, at the time a devoted Jehovah's Witness and facing controversy over the themes of the song and the content of the video, layered onto the opening of the music video a disclaimer that read: "Due to my strong personal convictions, I wish to stress that this film in no way endorses a belief in the occult."
12 Ed Vuilamy, "Nixon's War on Drugs Began 40 Years Ago and the Battle Is Still Raging," *Guardian*, July 24, 2011, theguardian.com.
13 Austin James and Aaron David McVey, "The 1989 NCCD Prison Population Forecast: The Impact of the War on Drugs, San Francisco, CA: National Council on Crime and Delinquency," 1989.
14 "Still Smokin': 30 Years of Crack's Influence on Pop Culture," *Ebony*, May 2, 2014, ebony.com.
15 "'Thriller' (original upload)," YouTube video, posted by @byronfgarcia, July 17, 2007.
16 "Origin of HIV and AIDS," *Be in the Know*, updated August 25, 2022, beintheknow.org.

17 In reference to the 1968 film *Night of the Living Dead*, dir. George Romero. W. R. Greenfield, "Night of the Living Dead II: Slow Virus Encephalopathies and AIDS; Do Necromantic Zombiists Transmit HTLV-III/LAV during Voodooistic Rituals?," *Journal of the American Medical Association* 256, no. 16 (October 1986), pp. 2199–200.
18 "Michael Jackson, 'Thriller,'" *1980s Music Video Closet*, videocloset blog.wordpress.com.
19 "Birth of a Nation The Chase 20140227 065629 27," YouTube video, posted by @pintanalley, February 27, 2014.
20 Mike Mariani, "The Tragic, Forgotten History of Zombies," *Atlantic*, October 28, 2015, theatlantic.com.
21 Rund Abdelfatah and Laine-Kaplan-Levenson, "A History of Zombies in America," NPR, October 31, 2019, npr.org.

6. PARIS IS BURNING

1 Fred Moten, quoted in *On Value*, ed. Ralph Lemon, New York: Triple Canopy, 2015, p. 117.
2 Langston Hughes, *The Collected Works of Langston Hughes*, Columbia, MO: University of Missouri Press, 2001, p. 208.
3 Judith Butler, "Gender Is Burning," *Bodies That Matter: On the Discursive Limits of 'Sex,'* New York: Routledge, 1993, p. 129.
4 Madison Moore, *FABULOUS: The Rise of the Beautiful Eccentric*, New Haven, CT: Yale University Press, 2018, p. 55.
5 Brian Harper, "'The Subversive Edge': Paris Is Burning, Social Critique, and the Limits of Subjective Agency," *Critical Crossings*, vol. 24, nos. 2/3 (Summer/Autumn 1994), pp. 90–103.
6 Jennifer Dunning, "An Exotic Gay Subculture Turns Poignant under Scrutiny," *New York Times*, March 23, 1991, nytimes.com.
7 K. Austin Collins, "Paris Is Burning Is Back—and So Is Its Baggage," *Vanity Fair*, June 18, 2019, vanityfair.com.
8 Jesse Green, "Paris Has Burned," *New York Times*, April 18, 1993, nytimes.com.
9 Ibid.
10 bell hooks, "Is Paris Burning?," in *Black Looks: Race and Representation*, Boston: South End Press, 1992.
11 bell hooks and Isaac Julien, "States of Desire Transition," *Transition*, no. 53 (1991), pp. 168–84.
12 Maureen Corrigan, "'Let the People See': It Took Courage to Keep Emmett Till's Memory Alive," WBUR, October 30, 2018, wbur.org.
13 Dunning, "Exotic Gay Subculture."
14 Green, "Paris Has Burned."

15 Ashley Clark, "Burning Down the House: Why the Debate over Paris Is Burning Rages On," *Guardian*, June 24, 2015, theguardian.com.

16 Ibid.

17 Essex Hemphill, "Paris Is Burning Illusions Were Never So Real," *Guardian*, July 3, 1991.

18 Christina Sharpe, *In the Wake: On Blackness and Being*, Durham, NC: Duke University Press, 2016, p. 14.

19 E. Patrick Johnson, *Appropriating Blackness: Performance and the Politics of Authenticity*, Durham, NC: Duke University Press, 2003, p. 82.

20 Collins, "Paris Is Burning Is Back."

21 Keith Townsend Obadike, interviewed by Coco Fuso, "All Too Real: The Tale of an On-Line Black Sale," *Mendi and Keith Obadike* (official website), September 24, 2001, blacknetart.com.

22 manuel arturo abreu, "Online Imagined Black English," *Arachne*, n.d., arachne.cc.

23 James Baldwin, "If Black English Isn't a Language, Then Tell Me, What Is?," *New York Times*, July 29, 1979.

24 Brock, *Distributed Blackness*, pp. 86, 82.

25 "In Conversation: Fred Moten and Legacy Russell," YouTube video, posted by @hauserwirth, January 22, 2021; Jack Whitten, *Jack Whitten: Notes from the Woodshed*, New York: Hauser & Wirth, 2018.

26 Brock, *Distributed Blackness*, p. 138.

27 Jih-Fei Cheng, "Keep It on the Download: The Viral Afterlives of Paris Is Burning," in *Queer Nightlife*, ed. Kemi Adeyemi, Kareem Khubchandani, and Ramón H. Rivera-Servera, Ann Arbor: University of Michigan Press, 2021, p. 238.

28 Rashaad Newsome, interviewed by David Balzer, "Rashaad Newsome on Voguing, Heraldry, and FKA Twigs," *Momus*, June 10, 2015, momus.ca.

29 Allucquère Rosanne Stone, *The War of Desire and Technology at the Close of the Mechanical Age*, Cambridge, MA: MIT Press, 1995, p. 14.

30 Ibid., p. 15

31 Taylor Lorenz, "The Original Renegade," *New York Times*, February 13, 2020, nytimes.com.

32 D. Bondy Valdovinos Kaye, "TikTok Is Partnering with a Blockchain Start-up. Here's Why This Could Be Good News for Artists," *Conversation*, August 20, 2021, theconversation.com.

33 Kara Keeling, "Queer OS," *Cinema Journal*, vol. 53, no. 2 (2014), p. 153.

34 Ligon, "Notes on a Performance by Kellie Jones," p. 79.

7. REALITY, TELEVISED

1 Caleb Azumah Nelson, *Open Water*, New York: Viking, 2021, p. 85.
2 Katherine McKittrick, *Demonic Grounds: Black Women and the Cartographies of Struggle*, Minneapolis: University of Minnesota Press, 2006.
3 Ryan Broderick, "'Trayvoning' Is a New Horrible Trend Where Teenagers Reenact Trayvon Martin's Death Photo," *Buzzfeed News*, July 26, 2013, buzzfeednews.com.
4 Kemi Adeyemi, "Beyond 90°: The Angularities of Black/Queer/Women/Lean," *Women and Performance: A Journal of Feminist Theory* 29, no. 1 (February 5, 2019), pp. 9–24.
5 Devin Kenny, "Untitled/Clefa," *Rhizome: Net Art Anthology*, 2013, anthology.rhizome.org.
6 Imani Perry, *Looking for Lorraine: The Radiant and Radical Life of Lorraine Hansberry*, Boston: Beacon Press, 2018, p. 22.
7 Philip Lewis, "Diamond Reynolds' Facebook Video Shows Police Shooting of Philando Castile in Minnesota," *Mic*, July 7, 2016, mic.com.
8 Erik Ortiz, "George Holliday, Who Taped Rodney King Beating, Urges Others to Share Videos," NBC News, July 9, 2015.
9 Independent Commission on the Los Angeles Police Department, *Report of the Independent Commission on the Los Angeles Police Department*, 1991, available at Internet Archive, archive.org.
10 Ibid.
11 "Man Who Taped Beating Seeks Payment," *New York Times*, June 5, 1991, nytimes.com.
12 Azi Paybarah, "He Videotaped the Rodney King Beating. Now, He Is Auctioning the Camera," *New York Times*, July 29, 2020, nytimes.com
13 Ibid.
14 Clay Risen, "George Holliday, Who Taped Police Beating of Rodney King, Dies at 61," *New York Times*, September 22, 2021, nytimes.com.
15 George Holliday, "First Ever Viral Video: Rodney King Beating Video," rodneykingvideo.com.ar.
16 Hector Tobar and Richard Lee Colvin, "From the Archives: Accounts of Rodney Glen King's Arrest Describe Repeated Striking and Kicking of the Suspect," *Los Angeles Times*, March 7, 1991, latimes.com.
17 Seth Mydans, "Jury Could Hear Rodney King Today," *New York Times*, March 9, 1993, nytimes.com.
18 Dennis McDougal, "Few L.A. Outlets for Live Coverage of King Trial: Television: Most Local Cable Systems Do Not Carry Court TV. Many Stations Will Plug Into Pool Feed but Plan Limited Air

Time," *Los Angeles Times*, February 26, 1992, latimes.com.

19 "Court TV Net Finds Itself on a Major Roll," *Variety*, January 29, 1995, variety.com.

20 Lou Cannon, "The King Incident: More Than Met the Eye on Videotape," *Washington Post*, January 25, 1998, washingtonpost.com.

21 Elizabeth Alexander, "'Can You Be BLACK and Look at This?': Reading the Rodney King Video(s)," *Public Culture* 7, no. 1 (1994), pp. 79–80.

22 Risen, "George Holliday."

23 "Court TV—The "Rodney King" Case:," YouTube video, posted by @mozorael8165, May 22, 2016.

24 Suzanne Muchnic, "King Beating Footage Comes to the Art World: Art: George Holliday's Tape Represents 'a New Way of Seeing What Is around Us,' Says the Whitney Curator Who Chose It for the Museum's Biennial," *Los Angeles Times*, March 10, 1993, latimes.com.

25 Deborah Soloman, "The Art World Bust," *New York Times*, February 28, 1993, nytimes.com.

26 Roberta Smith, "At the Whitney, a Biennial with a Social Conscience," *New York Times*, March 5, 1993, nytimes.com.

27 Muchnic, "King Beating Footage Comes to the Art World."

28 "Thelma Golden," *Charlie Rose*, February 27, 1995, charlierose.com.

29 Thelma Golden and Thomas J. Lax, "'Black Male' (1994–95)," *Artforum*, Summer 2016, artforum.com.

30 Paul Reid, "Blame It on Suburbia," *Boston Globe*, May 1, 1992, bostonglobe.newspapers.com.

31 John Eligon, "Michael Brown Spent Last Weeks Grappling with Problems and Promise," *New York Times*, August 24, 2014, nytimes.com.

32 João Costa Vargas and Joy A. James, "Refusing Blackness-as-Victimization: Trayvon Martin and the Black Cyborgs," in *Pursuing Trayvon Martin: Historical Contexts and Contemporary Manifestations of Racial Dynamics*, ed. George Yancy and Janine Jones, Lanham, MD: Lexington Books, 2012.

33 Ibid., p. 197.

34 Yancy and Jones, *Pursuing Trayvon Martin*, p. 16.

35 Christina Sharpe, *In the Wake: On Blackness and Being*, Durham, NC: Duke University Press, 2016, p. 15.

36 Sylvia Wynter, "No Humans Involved," *Knowledge for the 21st Century* 1, no. 1 (Fall 1994).

37 "NHI," applied by the LAPD to King, also has a history of application to other marginalized subjects—including trans people, sex workers, and people of color—the impact of which arcs to the present day.

38 Zakiyyah Iman Jackson, *Becoming Human: Matter and Meaning in*

an Antiblack World, New York: New York University Press, 2020, p. 9.
39 Nana Kwame Adjei-Brenyah, *Friday Black*, Boston: Mariner, 2018, p. 88.
40 Angel Jennings, "Rodney King's Daughter Remembers a Human Being, Not a Symbol," *Los Angeles Times*, March 3, 2016, latimes .com.
41 Jennifer Medina, "Rodney King Dies at 47; Police Beating Victim Who Asked 'Can We All Get Along?,'" *New York Times*, June 17, 2012, nytimes.com.
42 Jennings, "Rodney King's Daughter Remembers."

8. REFUSING SYMBOLISM

1 Toni Morrison, *Race-ing Justice, En-gendering Power*, New York: Knopf, 1992, p. viii.
2 Nicole Fleetwood, *Racial Icons: Blackness and the Public Imagination*, New Brunswick, NJ: Rutgers University Press, 2015, pp. 1–2.
3 "October 11, 1991: Anita Hill Full Opening Statement (C-SPAN)," YouTube video, posted by @cspan, September 21, 2018.
4 bell hooks and Isaac Julien, "States of Desire Transition," *Transition*, no. 53 (1991), pp. 168–84.
5 Robin D. G. Kelley, foreword to Cedric J. Robinson, *Black Marxism: The Making of the Black Radical Tradition*, Chapel Hill: University of North Carolina Press, [1983] 2000, xix.
6 Herbert Marcuse, "Remarks on a Redefinition of Culture," *Daedalus* 94, no. 1 (1965), pp. 190–207.
7 Jared Sexton, "The Social Life of Social Death: On Afro-Pessimism and Black Optimism," *InTensions*, no. 5 (November 2011).
8 "Hearing Captures Big TV Audience," *New York Times*, October 13, 1991, nytimes.com.
9 Kodwo Eshun and Ros Gray, "The Militant Image: A CinéGeography," *Third Text* 25, no. 1 (2011).
10 Legacy Russell, "It's a Damned Shame! The Theater and Purgatory of the American 'Perp Walk,'" *Berfrois*, February 7, 2013, berfrois.com.
11 Roland Barthes, *Image Music Text*, London: Fontana Press, 1977, 142.
12 L. A. Grindstaff, "Double Exposure, Double Erasure: On the Frontline with Anita Hill," *Cultural Critique*, no. 27, (Spring 1994), 30.
13 Boris Groys, "Religion in the Age of Digital Reproduction," *e-flux*, March 2009, e-flux.com.
14 Morrison, *Race-ing Justice, En-gendering Power*, p. x.
15 Vincent Woodard, *The Delectable Negro*, New York: New York University Press, 2014, p. 14.

16 James Snead, "On Repetition in Black Culture," *Black American Literature Forum* 15, no. 4 (Winter 1981), 146–54.

17 Also known as Lisa E. Harris.

18 Li Harris, "A Performer's Response to Dead Performance Online," *LI(SA((E.))HARRIS*, May 27, 2020, lisaeharris.com.

19 Taylor Lorenz, "The Original Renegade," *New York Times*, February 13, 2020, nytimes.com

20 "Magic Johnson HIV announcement Part 1," YouTube video, posted by @cnn, November 4, 2011.

21 "Mortality Attributable to HIV Infection/AIDS Among Persons Aged 25–44 Years—United States, 1990, 1991," Centers for Disease Control and Prevention, July 2, 1993, cdc.gov.

22 Achille Mbembe, *Necropolitics*, Durham, NC: Duke University Press, 2019. Gratitude to Achille Mbembe for this book and the work it does here to deepen this dialogue, through and beyond a discussion of Johnson.

23 Johanna Hedva, "Sick Woman Theory," *Topical Cream*, March 12, 2022, topicalcream.org.

24 Lou Cannon and Anthony Cotton, "Johnson's HIV Caused by Sex," *Washington Post*, November 9, 1991, washingtonpost.com.

25 Ibid.

26 Philip J. Hilts, "Magic Johnson Quits Panel on AIDS," *New York Times*, September 26, 1992, nytimes.com.

27 Masha Gessen, "George H. W. Bush's Presidency Erased People with AIDS. So Did the Tributes to Him," *New Yorker*, December 7, 2018, newyorker.com.

9. "THE DANCING BABY"

1 Brooke Marine, "Cassandra Press Redefines the Way Black Critical Theory Is Taught," *W Magazine*, September 2, 2020, wmagazine.com.

2 Jason Lederman, "I Created the First Digital Meme," *Popular Science*, May 25, 2018, popsci.com.

3 Marine, "Cassandra Press."

4 Hito Steyerl, "Too Much World: Is the Internet Dead?," *e-flux*, November 2013, e-flux.com.

5 See "The Talismanic Image," in Lorraine Daston and Peter Galison, "The Image of Objectivity," *Representations*, no. 40 (Autumn 1992), p. 81.

6 Matthew Mirapaul, "Oh, Baby! The Story of a Toddler Who Traveled the Web," *New York Times*, July 24, 1997, archive.nytimes.com.

7 Lederman, "First Digital Meme."

8 Harvey Young, "The Black Body as Souvenir in American Lynching," *Theatre Journal* 57, no. 4 (December 2005), p. 640.

9 Kenneth Schweitzer, *The Artistry of Afro-Cuban Bata Drumming: Aesthetics, Transmission, Bonding, and Creativity*, Jackson: University Press of Mississippi, 2013.
10 Whitney Friedlander, "Where Do Dancing Babies Come From? The Story behind the Classic Ally McBeal Scene," *Vulture*, October 9, 2020, vulture.com.
11 David Barboza, "Enter Geekdom's Diaper Dandy. Can You Explain This, Sigmund?," *New York Times*, January 26, 1998, nytimes.com.
12 Jean Baudrillard, *Simulacra and Simulation*, Ann Arbor: University of Michigan Press, 1995, p. 3.

10. THE SHADOW, THE SUBSTANCE

1 Aria Dean, "Poor Meme, Rich Meme," *Real Life*, July 25, 2016, reallifemag.com
2 Black American activist and abolitionist Sojourner Truth sold small portraits to generate funds for her lecture engagements. Truth printed this on the photographs.
3 There are 207 points in total in the twenty-four-page filing that narrates the complaint and request for "equitable restitution" and trial by jury: Lanier v. President and Fellows of Harvard College, 2021–2022, SJC-13138.
4 Joey Garrison, "Who Was Renty? The Story of the Slave Whose Racist Photos Have Triggered a Lawsuit against Harvard," *USA Today*, March 22, 2019, usatoday.com.
5 Nicole Soto, "His Wife Discovered Century-Old Photos of Slaves. He Carries On Her Legacy in Phoenix," *AZ Central*, October 28, 2019, azcentral.com.
6 Parul Sehgal, "The First Photos of Enslaved People Raise Many Questions about the Ethics of Viewing," *New York Times*, September 29, 2020, nytimes.com.
7 Latria Graham, "The Dark Underside of Representations of Slavery," *Atlantic*, September 16, 2021, theatlantic.com.
8 "From Here I Saw What Happened and I Cried," MoMa Learning, moma.org; "Carrie Mae Weems in 'Compassion,'" *Art21*, October 7, 2009, art21.org.
9 Sasha Bonét, "Carrie Mae Weems Confronts the Fraught History of American Photography," *Aperture*, April 9, 2021, aperture.org.
10 Jennifer Schuessler, "Your Ancestors Were Slaves. Who Owns the Photos of Them?," *New York Times*, April 1, 2019, nytimes.com.
11 Latria Graham, "What Are the Legal Rights of Deceased Black Americans?," *Atlantic*, September 17, 2021, theatlantic.com.
12 Ibid.
13 Ganesh Setty, "A Judge Ruled Photos of Enslaved Individuals Belong

to Harvard, Not Their Direct Descendant," CNN, March 5, 2021, cnn.com.

14 Sarah Jorgensen, "Harvard Professor in 1800s Had Photos Taken of Slaves. Now His Family Wants the School to Give the Images to Their Descendants," CNN, June 20, 2019, cnn.com.

15 Setty, "Photos of Enslaved Individuals." Recall here the three-fifths compromise, which mandated that every five slaves would be counted as three people in the population count toward taxation and representation, as protected by the United States and enacted at the United States Constitutional Convention in 1787 in an agreement between delegates of northern and southern states.

16 Matthew S. Schwartz, "Harvard Profits from Photos of Slaves, Lawsuit Claims," NPR, March 21, 2019, npr.org.

17 Setty, "Photos of Enslaved Individuals."

18 Maya H. McDougall and Garrett W. O'Brien, "Five Generations of Renty," Harvard Crimson, March 18, 2021, thecrimson.com.

19 Gillian Brockell, "Court Rules Purported Descendant of Enslaved Man Can Sue Harvard," Washington Post, June 23, 2022, washington post.com.

20 Ibid.

21 Anemona Hartocollis, "Who Should Own Photos of Slaves? The Descendants, Not Harvard, a Lawsuit Says," New York Times, March 21, 2019, nytimes.com.

22 Ariella Aïsha Azoulay, "The Captive Photograph," Boston Review, September 23, 2021, bostonreview.net.

23 Susan Stewart, On Longing: Narratives of the Miniature, the Gigantic, the Souvenir, and the Collection, Baltimore, MD: Johns Hopkins University Press, 1984, pp. 136, 140.

24 "Shades of Intimacy: What the Eighteenth Century Teaches Us," video, Cornell University, May 27, 2016, cornell.edu.

25 Nicole R. Fleetwood, On Racial Icons: Blackness and the Public Imagination, New Brunswick, NJ: Rutgers University Press, p. 25.

26 Tina M. Campt, Listening to Images, Durham, NC: Duke University Press, 2017.

27 Jean Baudrillard, The System of Objects, trans. James Benedict, London: Verso, 1996, p. 1.

28 Ibid., p. 5; Sarah Elizabeth Lewis, "The Insistent Reveal: Louis Agassiz, Joseph T. Zealy, Carrie Mae Weems, and the Politics of Undress in the Photography of Racial Science," in To Make Their Own Way in the World: The Enduring Legacy of the Zealy Daguerreotypes; The Insistent Reveal Chapter, ed. Ilisa Barbash, Molly Rogers, and Deborah Willis, New York: Aperture, 2020.

29 John Stauffer et al., Picturing Frederick Douglass: An Illustrated Biography of the Nineteenth Century's Most Photographed American, New York: Liveright, 2015, p. 128.

30 "Massachusetts Senate Passes 'Right of Publicity' for the Dead,"
 WBUR, June 13, 2014, wbur.org.
31 Andrew Gilden, "Sex, Death and Intellectual Property," *Harvard
 Journal of Law and Technology* 32, no. 1, (Fall 2018), pp. 93–4.
32 Ibid., p. 95
33 Graham, "Legal Rights."
34 Baudrillard, *Simulacra and Simulation*, p. 6.

11. MEME AFTERLIVES

1 Kathleen Collins, *Whatever Happened to Interracial Love?*, New
 York: Ecco, 2016, pp. 1–3.
2 Yousar Al-Hlou, "Philando Castile, Diamond Reynolds and a Night-
 mare Caught on Video," *New York Times*, June 23, 2017, nytimes
 .com.
3 Ibid.
4 Merrit Kennedy, "Live Video after Police Shooting Brings New
 Immediacy to Bearing Witness," NPR, July 7, 2016, npr.org; Daniel
 D'Addario, "The Legacy of Diamond Reynolds' Video," *Time*, July
 8, 2016, time.com.
5 Al-Hlou, "Philando Castile, Diamond Reynolds."
6 Eliott C. McLaughlin, "Woman Streams Aftermath of Fatal Officer-
 Involved Shooting," CNN, July 8, 2016, cnn.com.
7 Kennedy, "Live Video."
8 Danielle Paquette, "'This Is the Brain on Horror': The Incredible
 Calm of Diamond 'Lavish' Reynolds," *Washington Post*, November
 24, 2021, washingtonpost.com.
9 Maureen Corrigan, "'Let the People See': It Took Courage to Keep
 Emmett Till's Memory Alive," WBUR, October 30, 2018, wbur.org.
10 "Diamond Reynolds July 6, 2016 Facebook Live Video (WARNING:
 Graphic content)," YouTube video, posted by @RamseyCountyMN,
 June 20, 2017.
11 Adrian Humphreys, "Calm in the Face of Death: Diamond Reyn-
 olds' Remarkable Live Streaming of Boyfriend's Shooting by Police,"
 National Post, July 7, 2016, nationalpost.com.
12 Richard A. Oppel Jr., Derrick Bryson Taylor, and Nicholas Bogel-
 Burroughs, "What to Know about Breonna Taylor's Death," *New
 York Times*, March 9, 2023, nytimes.com.
13 "Death of Breonna Taylor," Know Your Meme, 2020, knowyour
 meme.com.
14 Minyvonne Burke, "Lawsuit Says Police May Have Lied about
 Breonna Taylor Body Camera Footage," NBC News, July 9, 2021,
 nbcnews.com.
15 Malachy Browne et al., "How the Police Killed Breonna Taylor,"

New York Times, December 28, 2020, nytimes.com.

16 Joseph Wilkinson, "Lili Reinhart Apologizes for Posting Sideboob Photo, Connecting It to Breonna Taylor's Death," *New York Daily News*, June 30, 2020, nydailynews.com.

17 "Death of Breonna Taylor."

18 Note that this hashtag did not rise out of the murder of Taylor but rather originated in 2014, driven by the African American Policy Forum and the Center for Intersectionality and Social Policy Studies initiatives to advance discourse on racial justice.

19 Aja Romano, " 'Arrest the Cops Who Killed Breonna Taylor': The Power and the Peril of a Catchphrase," *Vox*, August 10, 2020, vox .com.

20 Arthur Ashe, May 26, 1992, press conference.

21 "If It Bleeds, It Leads," *TV Tropes*, tvtropes.org.

22 Legacy Russell (@legacyrussell), "The aestheticization of #Breonna Taylor is unacceptable. It is not radical to make her image decorative," Twitter, August 24, 2020, twitter.com.

23 Zeba Blay, "The Memeification of Breonna Taylor's Death," *Huffington Post*, July 2, 2020, huffpost.com.

24 Adrienne L. Childs, "Sugar Boxes and Blackamoors: Ornamental Blackness in Early Meissen Porcelain," in *The Cultural Aesthetics of Eighteen-Century Porcelain*, ed. Alden Cavanaugh and Michael E. Yonan, New York: Routledge, 2010, p. 159.

25 Lorraine O'Grady, "Olympia's Maid: Reclaiming Black Female Subjectivity," *Art Activism and Oppositionality*, Durham, NC: Duke University Press, 1998.

26 K. J. Greene, " 'Copynorms,' Black Cultural Production, and the Debate over African-American Reparations," *Cardozo Arts and Entertainment Law Journal* 25, no. 3 (2008), p. 1179.

27 Ibid., p. 1181

28 Anjali Vats and Deidre A. Keller, "Critical Race IP," *Cardozo Arts and Entertainment Law Journal* 36, no. 3 (2017), p. 743.

29 For an excerpt, see Norman Mailer, "The White Negro (Fall 1957)," *Dissent*, June 20, 2007, dissentmagazine.com.

30 K. J. Greene, "Intellectual Property at the Intersection of Race and Gender: Lady Sings the Blues," *Journal of Gender, Social Policy, and the Law* 16, no. 3 (2008), p. 379.

Outro in Remix

1 "Race, Identity, and Performance in Danzy Senna's 'New People,' " NPR, September 5, 2017, npr.org.

2 Charles Baudelaire, "Les Foules," *Le Spleen de Paris*, in *Oeuvres Completes*, vol. 1, pp. 420–1.

3 "Ama Badu Helps Write Shudu's Story and Gives Her a Voice," *Diigitals*, thediigitals.com.
4 Tony Ho Tran, "OpenAI's Impressive New Chatbot Isn't Immune to Racism," *Daily Beast*, December 5, 2022, thedailybeast.com.
5 Gwendolyn Brooks, *Very Young Poets*, Chicago: Third World Press, 1979.